14 DAY BOOK

**This book is due on or before
the latest date stamped below**

ENGUINS

IST PAINTING

URNE

0s

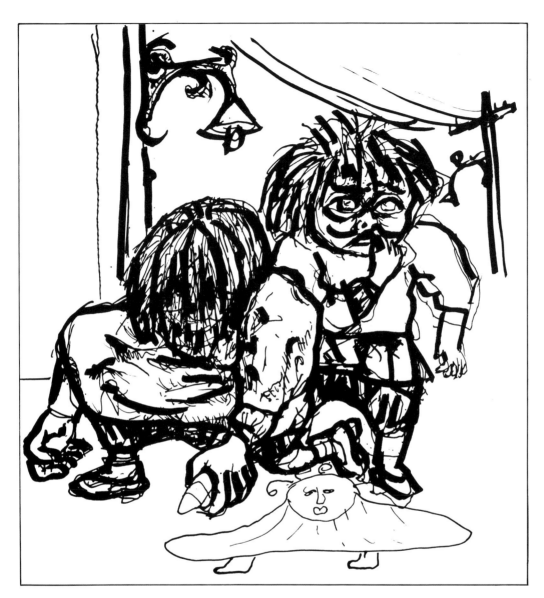

John Perceval
Children in a Carlton street
c.1942
Australian National Gallery, Canberra
No.139

ANGRY PENGUINS

AND REALIST PAINTING
IN MELBOURNE
IN THE 1940s

Hayward Gallery, London
19 May to 14 August 1988

Organised by the South Bank Centre,
the Australian National Gallery and
the Australian Bicentennial Authority

SOUTH BANK CENTRE

'Angry Penguins' is the title of a literary journal
founded and owned in South Australia by Max Harris,
the title deriving from one of his poems. The South
Bank Centre would like to acknowledge this and thank
him for permission to use it in the titling of this
exhibition.

Catalogue edited by Marianne Ryan
designed by Archetype Graphic Design
printed by Lund Humphries, London and Bradford

Exhibition Assistant Judy Duguid

Photographs have been provided by lenders to the exhibition.
The South Bank Centre would also like to acknowledge
and thank the following: Associated Press Ltd, Richard
Haese, Vic O'Connor, John Sinclair, Albert Tucker.

Front cover:
Albert Tucker
Sunbathers (detail)
1944
Australian National Gallery, Canberra
No.64

ACKNOWLEDGEMENTS

This exhibition began with a suggestion from the British curators Richard Francis and Sandy Nairne that the Hayward Gallery should show Australian painting of the 1940s, particularly those artists associated with the *Angry Penguins* magazine. They put this proposal to the Hayward Gallery and to the Australian Bicentennial Authority. It was accepted with enthusiasm by both. In turn the Australian Bicentennial Authority approached the Australian National Gallery in Canberra, the strength of whose collections in this field made it an obvious choice, to see if the Gallery would be able to undertake the co-ordination of such a project.

Once the collaboration was agreed and showing dates in 1988 established, the problems began. Paramount amongst them were the difficulties of squeezing yet another project into the Bicentennial year. Every Australian gallery, it seemed, had full schedules. Despite their heavy internal exhibition commitments the Australian galleries responded to the challenge of this show and we are especially grateful to them for the way in which they have met our demands. But some institutions were unable to collaborate, and for this reason a number of important works were not available.

However, that said, the final selection is quite exceptional and our first and foremost expression of gratitude must go to those galleries and individuals who have lent works from their collections for the greater part of this most important year. We should especially like to thank the Director and staff of the Art Gallery of South Australia, Adelaide; the Director and staff of the Art Gallery of New South Wales, Sydney; and the Director, Maudie Palmer, of Heide Park and Art Gallery, Bulleen, Victoria; all of whom have lent significant groups of works. In addition we have been fortunate in obtaining single loans of great importance for our subject from the Art Gallery of Western Australia, Perth; the University Art Museum of the University of Queensland; and the Australian War Memorial, Canberra. To them and to the few but crucial private lenders we offer our grateful thanks.

The organizing of the project has been the responsibility of Sara Kelly of the Australian National Gallery, Judy Annear of the Australian Bicentennial Authority, and Andrew Dempsey of the Hayward Gallery. A great many people have given advice, some of whom – Max Harris, Barrett Reid, Bernard Smith and Janine Burke – have also contributed to this catalogue. Others of whom we would like to make special mention include Richard Haese whose key book on Australian art of this period, *Rebels and Precursors*, has been an indispensable source of information throughout our preparations; Georges Mora of the Tolarno Galleries in Melbourne; Elizabeth Churcher, formerly Chair of the Visual Arts Board of the Australia Council (a body which has been supportive of the project since its inception) and now Director of the Art Gallery of

Western Australia, Perth; the artist James Gleeson; Stuart Purves of the Australian Galleries, Melbourne; Shirley Wagner of the Wagner Art Gallery, Sydney; the writer Ian Burn; Jan Minchin and Jane Clark, Curators at the National Gallery of Victoria; Professor Virginia Spate and Associate Professor Terry Smith of Sydney University; the writer and film-maker Helen Grace; Patsy Zeppel of the British Council; Leon Paroissien and Bernice Murphy of the Power Gallery of Contemporary Art, Sydney. And there are many others, too numerous to mention here. We owe thanks also to the departments of Registration and Conservation at the Australian National Gallery, and to the departments of Australian Art, photographic services, and those in administrative areas who backed them.

The subject of our exhibition is a period of very recent history. Many of the artists and participants in the story are still working, and still arguing as is evident in the pages of this catalogue. To the real begetters of this exhibition – to Yosl Bergner, Arthur Boyd, Sir Sidney Nolan, Vic O'Connor, John Perceval, Albert Tucker and to their fellow artists who are no longer alive – we offer our heartfelt thanks and our hope that this account of their early lives and the vital contribution they have made to art in Australia does them justice.

James Mollison
Director, Australian National Gallery

Peter Sarah
Director, Arts and Entertainment, Australian Bicentennial Authority

Joanna Drew
Director, Hayward and Regional Exhibitions, South Bank Centre

LENDERS TO THE EXHIBITION

Australian National Gallery, Canberra
Art Gallery of South Australia, Adelaide
Heide Park and Art Gallery, Melbourne
Art Gallery of New South Wales, Sydney
Art Gallery of Western Australia, Perth
University Art Museum, University of Queensland
Australian War Memorial, Canberra

Mr and Mrs M. Alter
Mr M. J. Dougherty
Mr and Mrs Alan Geddes
The Robert Holmes à Court Collection
John Perceval
Professor Bernard Smith
Albert Tucker

and private collectors

FOREWORD

'I would rather fill my history with great men and women, philosophers, scientists, intellectuals, artists, but I confess myself incapable of so vast a lie. I am stuck with Badgery and Goldstein (Theatricals) wandering through the 1930s like flies on the face of a great painting, travelling up and down the curlicues of the frame complaining that our legs are like lead and the glare from all the gilt is wearying our eyes, arguing about the nature of life and our place in the world while – I now know, Niels Bohr was postulating the presence of the neutrino, while matter itself was being proved insubstantial, while Hitler – that black spider – was weaving his unholy lies.

'Lies, dreams, visions – they were everywhere. We brushed them aside as carelessly as spider webs across a garden path. They clung to us, of course, adhered to our clothes and trailed behind us but we were too busy arguing to note their presence.'

Peter Carey, *Illywhacker*, University of Queensland Press, Australia, and Faber and Faber, London, 1985, p.326.

This exhibition started from the discovery (or rather uncovering) of our ignorance of most art in Australia, but in particular of the work of the late 1930s and 1940s, whose impact was immediate and whose special qualities have remained with us since our first visits to Australia. We suppose now that we were looking for an 'Australian' art, an irresistible trail to follow since it allowed speculation about the histories and the nature of this familiar but other country. In this case we found, of course, the conjunction of a particularly sophisticated ancient culture, a close geographical proximity to the Far East,

residues of several dislocated European cultures and the leftover but pervasive dullness of Anglo-Saxon colonial life dominant since 1788. An essential Australianness was something that we could never have found, especially when so many others had tried to define and promote it already. An 'Australian' art was thus a chimera necessarily as elusive as any idea of a singular national art. Yet important for any consideration of the unresolvable question of national identity was this set of works that we passionately wanted to exhibit in England. The Bicentennial celebrations provided us with an occasion and funding to make it possible. The exhibition project started without any intention that we should personally curate a group of works of which we had been so recently ignorant (partly because we were too young to have seen Bryan Robertson's Whitechapel exhibitions of Australian art and of Nolan's paintings) and thus the project could only emerge as a collaboration, both Australian and British, with a number of individuals who had, like the artists themselves, known much earlier than us the power and potential interest in this work.

We had been struck by the particular distinctiveness of these paintings, how different they were from the Surrealist and abstract works that had dominated the European avant-garde pre-war. The latter had, in the same period, been transported to America and formed the basis of the modernist influence behind American abstract expressionism of the 1950s. The Angry Penguins group and the realist painters in Melbourne enunciated a critique of the standard paradigms of modernism that were so readily accepted elsewhere (and indeed in Australia, in a weak and often debased form). There was a cussedness in this work, a determination to set itself apart from Eurocentric culture. This was apparent in Australian intellectual life (then and now): an ability to determine its own values through analysis of the issues and a determination not to repeat fashionable views parrot-fashion. It was an intellectual life less isolated than geography might suggest, but fuelled by debate with artists and writers in America, Europe and Britain, often through the *Angry Penguins* journal itself. Above all it was an intellectual life self-determined and assertive. In a simple way we can apply the same adjectives to our description of these paintings, adding that they are consistently more energetic than their European counterparts, that their painterly qualities are to the fore and that a message of the likely end of a distant civilization is conveyed with an energy and an appreciation of narrative not easily found in British paintings of the period.

Angry Penguins and Realist Painting in Melbourne in the 1940s masks the bitter divisions in the Australian painting debate and our title proposes the partial restaging of the conflict between only two of the several groups active at the time; the group associated with the Reeds (Boyd, Nolan, Tucker, Hester and Perceval) and the realists

(Counihan, O'Connor and Bergner, championed among others by the art historian Bernard Smith). As with other artistic dogfights, and as the chronology makes clear, the debate was only polarized at certain moments. Otherwise there were overlaps and elisions, and artistic interests ran to and fro between the public and the private, the individual and the social, the poetic and the scenic. The debate is presented in this exhibition not as an historical re-enactment but for its contemporary relevance, through a timely celebration of the individual works. The gloss on the debate underlying this exhibition animates terms like national and regional, expressionist and realist. We expect this work to deserve the same critical distinctions as, say, American Regionalism and those areas of British art considered especially British through their eccentricity or awkwardness. We are certain of more than this, and hope that the Australian contribution to a worldwide modernist movement will be given more careful consideration and be included in future histories. (We are both conscious, as former assistant keepers in the modern collection of the Tate Gallery, that the National Collection has almost entirely ignored the work of the artists in this exhibition and other significant art from the Commonwealth.)

These paintings from Melbourne undermine (and help to alter) the obvious stereotypes applied to Australian art: the colonial town, the great outback, the individual as outsider, the artist as storyteller. They are outstanding, awkward and uncomfortable, conveying brilliantly the difficulties of being an artist during the War and the peculiar detachment of a nation involved yet distanced from war, in a constantly shifting but ambivalent relationship with the 'mother country'.

Richard Francis
Sandy Nairne

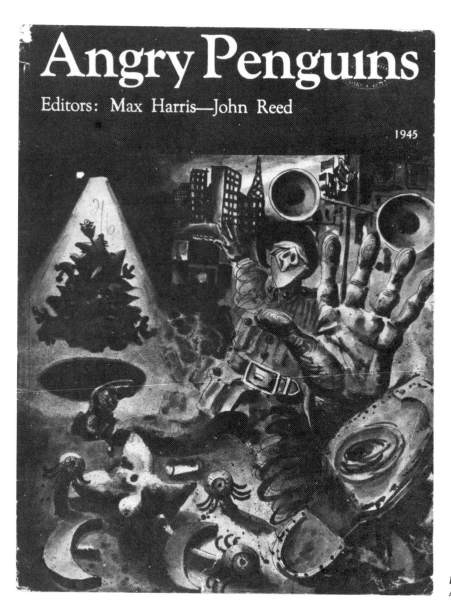

Front cover of
Angry Penguins, *1945*

INTRODUCTION
Max Harris

'As drunks,
The angry penguins of the night.'

With this none-too-serious line from one of my poems (suggested by Charles Rischbieth Jury, an Emeritus Professor of English Literature) a number of very young South Australian poets, painters, critics and political activists set out to establish one more little journal, and an identifiable form of 'Australian' creative modernism back in the 1940s.

We had not the slightest inkling that this catalytic exercise would result in the term 'Angry Penguins' which would be used for two decades by the conservative and philistine Establishment forces of the country as an expression of dismissal and contempt.

Then for the next two decades, the title became descriptive of a creative flowering, and an ideological renewal, which had changed the cultural shape and the psychology of a rather brutish and proudly anti-intellectual minor nation.

The title survives most appropriately for the descriptive purposes of this very exhibition.

As far as we were then concerned, it was simply a matter of a collection of young Rimbauds, intoxicated with an excess of free imagination, staggering out into the Australian dark, blithely indifferent to muggers, morons, the glares of the respectable,

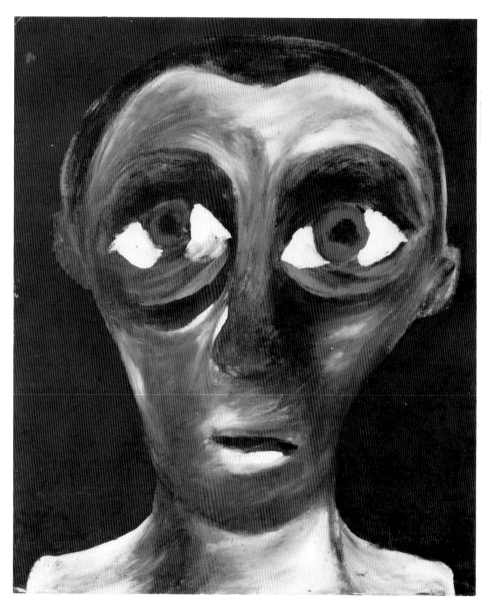

Sidney Nolan
S.N.
1947
Art Gallery of South Australia,
Adelaide
No.21

and the critical 'police' patrols employed by the authoritarian art establishments of the time.

That's how it felt in Australia's 1940s. Angry penguins were the sort of creatures we felt ourselves to be.

So far art historians and thesis writers have missed the point and counterpoint of the resultant movement.

The Melbourne Department of Fine Arts historians of the past decades have concentrated, with some understandable myopia, on the Melbourne ferment.

They've got the Melbourne point and missed the Adelaide counterpoint.

The first evangelistic break with lyrical and narrative realism in painting, and galloping balladry in poetry, came from an earlier South Australian movement, the 'Jindyworobaks', as they called themselves, after the Aboriginal word for 'meeting place'.

A young poet, Rex Ingamells, came up with a theory of 'environmental values'. He championed the conviction that Australia shouldn't be producing art forms which were but a variation on prevailing European themes. We should integrate with the existent ethnological culture, and invent idioms apt to our landscape and social relationships.

The results were forgettable. The seductions of the ideology were startlingly widespread all over the nation at this catalytic moment of national awareness, but there was little fierceness, nor light, in the works that were produced.

Poets wrote poems as if they were imitation 'black-fellows'. Painters exploited natural ochre colours in their paintings. It all changed in the Second World War years, with a late shift of purpose to politicization, and adherence to a movement called 'Australia First' which was anti-British, anti-Semite, and savagely isolationist. Pro-Australia was anti-British! The leadership was duly interned.

It was as if D. H. Lawrence had correctly guessed the shape of things to come in his quick prophetic transit, when he passed through Australia, and produced *Kangaroo* en passant.

The Angry Penguins group, however, increasingly absorbed European literary modernism and ideologies in all their forms.

The European idea of mythologizing from within the personal psyche was attractive, but too subjectively self-centred for what we needed to do within our unique, indigenous, petrified culture.

We had to reach into the imagery of the unconscious, and then superimpose it on our environment as an act of mythologizing the outside world.

In Australia a tree is not a tree is not a tree, as it were. It is part of the timber of the mind.

The time had come (despite Patrick White's later theory of environmental alienation) to express a white man's 'dreaming' in terms of poetry and painting.

For a number of simple reasons, the word then moved faster round the world than the visual image. Our outside models were to be found in Geoffrey Grigson's *New Verse* and, in America, *New Directions*.

But despite this, it was the young painters of distinguished sensibility who were thick on the ground all over Melbourne, not the poets.

Decorative modernism was getting some early acceptance up in Sydney. There were beginnings of what Robert Hughes in the course of time came to belatedly dub 'the Charm School'.

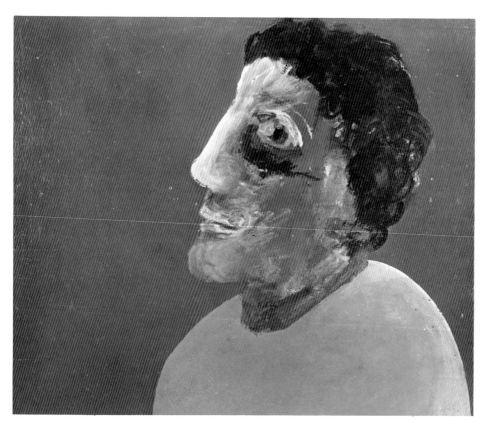

Sidney Nolan
J.R.
1944
Art Gallery of South Australia,
Adelaide
No.16.

But down in Melbourne it was felt to be not relevant for Australian artists to be producing belated Braques, home-grown Modiglianis, nor undistinguished surrealism, induced by the Freudian concepts so beautifully formulated by Sir Herbert Read in all those Faber books!

It was at this point of provincial confusion that John and Sunday Reed brought together the practical elements, the painters and poets, the intellectuals, the conceptualizing, and even unearthed a small responsive audience prepared to read and look.

They invited me and my *Angry Penguins* journal to migrate to Melbourne; they directed the inchoate subjectivity of magnificent young painters like Boyd, Perceval,

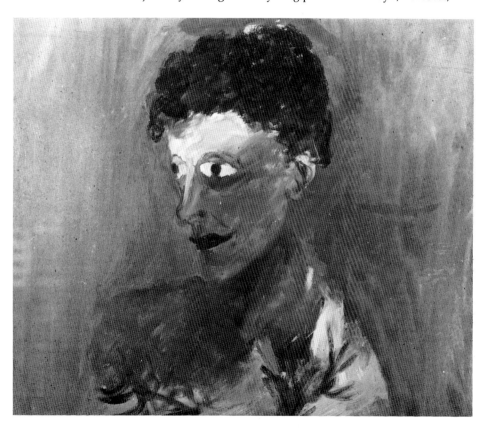

Sidney Nolan
S.R.
1947
Art Gallery of South Australia,
Adelaide
No.20

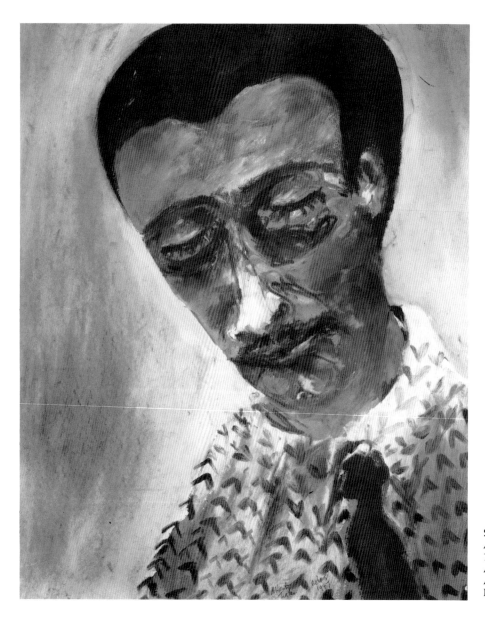

Sidney Nolan
Albert Tucker
1947
Art Gallery of South Australia,
Adelaide
No.23

Tucker and Nolan towards the idea of superimposing the private image on to a world outside the subjectivities of the ego. The landscape was to tell their personal stories.

Nolan and I intermittently resided at their home in semi-rural Heidelberg, and numerous other creative spirits came and went, using this centre as a sounding board for their painting and poetry (and even jazz), as well as the ideologies they'd thought up for their personal human condition – from wounded sensibility to social anger in a national landscape which was, unlike Europe, something of a forest of petrified minds.

No man is an island. But we came close to it!

Time, and the tide of things, have at last shown whether this most closely structured, most exclusive and excluded family of creativities contributed distinctively to the modern movement of the arts in the large. Contributed differently, and internationally.

What you see in this exhibition is what you judge. And it is the best possible time for judgements to be made from cool minds, and distanced sensibilities, in terms of both space and the passage of time, and the survival of the styles.

The exhibition is not merely a quick and usual gallop through a set of canvases and artefacts from a distant place.

It is almost a *request* for a final judgemental decision from you, distanced and objective viewers, to assess the quiddity and the oddity of how important art changes come into being, from any whichwhere. Even from Australia!

It was C. P. Snow who first came to the conclusion that Angry Penguins modernism was probably the last great flowering of a 'national' modernism that a completely internationalized world of the arts was likely to see.

This view, as I have frequently been told, was shared by Lord Clark.

Certainly, on the still-neglected literary side, it was a phenomenon which Sir Herbert Read kept telling me he found both stimulating and challenging, especially during the event of the 'Ern Malley' hoax poems, and my editorial prosecution for publishing indecent, immoral, and obscene matter, and the international furore it created in a great world-ranging debate on the sources of valid creativity.

Angry Penguins and the 'Ern Malley' hoax poems of 1944, and their subsequent prosecution by the police, provide a comic, ugly, and perplexing story. It has been well-recorded, and is still argued forty years on. But it is peripheral to the context of this exhibition.

The importance of the acclaimed 'phoney' poems was that they led to a greater anger, determination, and the diaspora of the Angry Penguins school.

Time magazine and the *New Statesman* were as bitterly divided on this hoax poetry

issue as were T. S. Eliot, Sean Jennett, Geoffrey Trease, Karl Shapiro, George Woodcock, and Herbert Read.

Regionally, alas, local yobdom had a field day.

Rancorous laughter spread all over. Hoax author, James McAuley, triumphantly went on to produce a book called *The End of Modernism*. The establishment art dictator, Sir Lionel Lindsay, published a book which attributed the spread of Picasso and Braque and Chagall to the world as a conspiracy which emanated from the Jewish art dealers of Paris.

The poetry of Ern Malley perdures forty years on even so. It lives on in itself; and in the intensities with which the artists reacted to the all-inclusive onslaught of cultural hatred.

That art was being produced under conditions of siege psychology means that there was, and still is, a problem with 'reading' Australian modernist art. The paintings are paintings; but many of them are also coded communication.

They are the work of highly original talents which were primarily those of 'artist' rather than 'painter'.

There is a subtle difference.

The work produced in the John and Sunday Reed years of the 1940s was psychobiographical. It came out of the pressures, pains, and passions and interactivity of a close circle of individuals.

It was a 'school' – just as surely as Bloomsbury was a 'school'.

But it passed without written record, biographical reminiscence, the peripheral presence of any sort of Boswell. It contrasts with Bloomsbury, where the reminiscences coloured the works purpler than they in fact prove to be in the reading, or viewing.

With us it was, and is, quite otherwise.

Today's paintings appear before you as if still wet on the easel. They cannot be understood in the historical context of what happened decades ago between Bert and Joy, John and Mary, between Sun and John, and any of us, or all of us. The forces that drove the painters to paint as they painted, are still obscure.

Do these psychobiographical lacunae matter? Not usually.

Here I think they do.

They matter because Angry Penguins modernism was not a matter of national style. The works you see are narrative, or pastoral-comical-tragical landscape, or rhetorical symbolism.

There is no paint-theory pattern to Australian modernism. No 'ism'. Each canvas accords with Rilke's idea of 'das Ding an sich'.

But the work intensifies in impact if there is an understanding of the psychic forces which produced it, and these, as I related to it at the time, were diverse and complex.

Indeed the Angry Penguins creative years accord with the William James notions of the bemusing varieties of religious and creative experience.

It would not have any relevance in the intrinsic failure or success of the individual paintings that hang on these walls. There might, however, be some contribution to the viewer's grasp of the works if I made comment, for the first time over all the years, on some of the psychological compulsions that drove, divided, and yet unified our Angry Penguins clan.

Indeed, this reading could well be extended to include our ideological antagonists, the Communist social realists, like Counihan and Bergner and their intellectual leader Bernard Smith. For they, too, were within that closed circle; within the walls of that antipodean Sebastopol. The golden dreams of a Persepolis were a long way off for all of us. Our Kropotkin anarchy was remote from their Stalinist conformity, but as Blake put it, with supreme wisdom, any friendship would have made the heart to ache. We were genuinely enemies, for friendship's sake.

The painter I think I loved best (even though my daily life was spent almost constantly in the companionship of Sidney Nolan) was John Perceval.

He was young amongst us old young people. He lived always being touched by a palpable pain which was partnered by a seethe of anger. With a deformed leg supported by irons, he was not a Byronic figure. Rather one felt he felt himself to be an inside outsider. He felt himself disadvantaged in educated, intellectual facility, even in terms of nearness to the familial bosom of John and Sunday Reed. He lacked the arrogant certitudes of those possessed by their craft. He was deeply in love with Arthur Boyd's sister, Mary, and yet felt that reciprocated love to be always under threat for no good reasons whatsoever.

Yet there was a rich store of love in him. Confused he may have been. Prickly he was. Tenderness kept battling with rage, and I loved him for the way he fought the losing fight with a sort of lonely courage.

In my view he painted the first unequivocal masterpiece of Australian modernism, *Boy with a cat*. Here was a painting which anticipated Francis Bacon, but which excelled Bacon's later work in the control of intolerable tensions. It has associations with the fashionable *Scream* (which Perceval had never seen) but the scream in Perceval's painting is a silence.

21

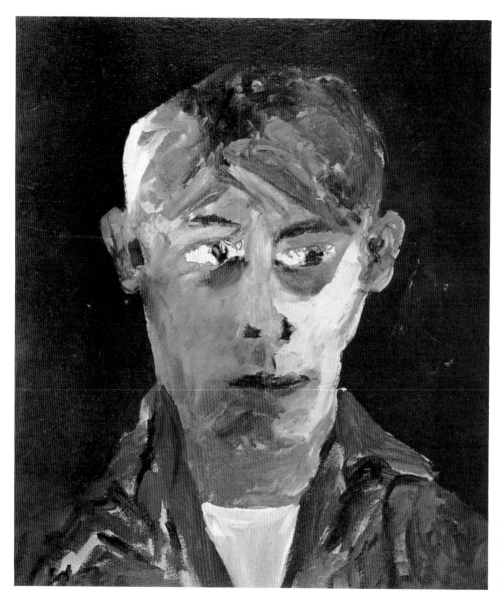

Sidney Nolan
J.P.
1945
Art Gallery of South Australia,
Adelaide
No.18

Perceval is worth careful study. He is not, I think, to be regarded as an exponent of an Australian Expressionism.

He has produced an art of defiance, a rare genre indeed. It can be sensed in the very application of the paint, and also in the anti-populist grotesquerie of his pottery.

His work is unusual, uncorrupted, in any terms of modern art in the large, and one day may be so recognized.

Psychobiographical volumes could be written about the inimitable Arthur Boyd.

His family home at Murrumbeena was a warm refuge for the painter in the artist. One was welcomed without question into an environment. It was a traditional family world in which only the profession of 'painting' had meaning. The outside world was a nonsense, and one ventured into it only as an eccentric. Many a time Arthur's gentle and lovely father wandered out into that world to become lost, and search parties had to be sent out to recover him. At Murrumbeena the art of painting was what one was in the world to do.

By contrast the Heidelberg safe-house of John and Sunday Reed was the place to go to find if you were an 'artist' – in any genre.

'Heide' was exacting and demanding in terms of the testing of sensibility. If you met the personal tests of inherent sensibility and creativity, John and Sun would fight your fights with fidelity and constancy.

Arthur was the first of his family to live in both worlds.

Superficially he was our 'child of nature', his rattle that of a simple man. He lived without the pleasures of malice, envy or competitiveness.

For the life of him he couldn't produce other than the kind word, nor find a cruel deed within his nature.

But saintliness is often shrewder than one thinks.

It can be a natural disguisement for all kinds of obsessions that are implanted in the darker depths of the unconscious.

Boyd extracted personal mythologies from the history of mythologies, from the Bible, from medievalism, from contemporary erotics, from the ruttings of the natural world, and externalized them on to familiar indigenous landscapes and the cultural folk-lores to be found in Australia at that time.

Arthur realized best, and with most wide-ranging creative originality, the ideology I was propounding as our national path to an indigenous modernism.

That is, we should eschew the self-indulgent private surrealist image, and project

such private imagery relevantly on to a common visible world, so that Australia would discover that without imagination people and places have no soul. And this was certainly true of Australia, circa 1944.

Albert Tucker is an example of the gifted artist who thinks too much, too hard, and too well.

In another context it would be interesting to narrate the bounce-off relationship between Tucker and his first wife, Joy Hester, who has been evaluated, belatedly, as our finest artist of feminine feminist sensibility. This is a separate story.

Albert Tucker was, and still is, an exemplar of art as the communicatory form of anger. Tucker has an urbane and urban mind. You can't be an Angry Penguin unless you are angry. Tucker viewed the urban world around him, and responded with non-political revolutionary statements in paint. He pinpointed the images of Australian evil, and put them down with remarkable technical skill. He found the world unjust. He even found his friends unjust. He found there was no rationale to the process of recognition.

His great works of the St. Kilda era will endure.

But then came the diaspora of the 'Ern Malley' era.

The Angry Penguins dispersed into the international art community to find their fame and fortune – perhaps. But some of them lost the intense integrity of their themes. What they were was here, not there.

Tucker symbolizes the passion and drive of the Angry Penguins movement, but the body of his life's work needs canons of critical judgement to be applied. When he painted from possession, he was a fine artist indeed. When he calculated his themes in the overseas alien corn, that's what he produced, the alien corn.

He has mellowed, and it could be that he will be the only Angry Penguin who will produce late great work in the tranquillity of recollection.

Let us turn to the enemy who was not with us, but still of us.

It is axiomatic that everywhere social realists are social realists.

There is a difference, however, between the Australian social realism of painters such as Counihan and O'Connor and others, and the European models.

Käthe Kollwitz was the great influence. But she drew the pity and the pathos of the human condition in the cause of political effect. She was a genius, but she was an

aesthetic manipulator.

In Australia the Communist Party was a pretty shoddy old show. It was too far from the action.

I know. I was in the communist business during my most youthful years.

The result of this whooped-up distant revolutionary zeal was that some of our social realists painted not for propagandist purposes, but out of simple personal anger and a sense of sociological injustice.

In short, they had an anger in common with the Angry Penguins, and were of the devil's party without knowing it.

That is why a painter such as Counihan has an enduring power and poignancy when most of his overseas breed are dead and forgotten.

I have made no comments on the most famous Angry Penguins painter of them all, Sidney Nolan.

Although I knew him best, and worked with him most of all, in fact I knew him least.

His mind was always cryptic, his purposes inscrutable, his behaviour had a logic of its own.

His life has been programmed, his stature evaluated by other minds, and in many market-places.

There is nothing I can say which would, in discussing the Kelly behind the mask, contribute to the world evaluation of his vast output.

It takes time, it takes distanced perspectives, it takes disinterested objectivity, for a tiny moment of the history of art to be evaluated.

Four decades is not a long time.

But as a close participant in the whole era, my feeling is that this exhibition is the most important testing of Australia's coming of age in the whole year of Bicentennial brouhaha.

I am grateful to those who conceived and carried out this imaginative, but above all, valuable project.

Sidney Nolan
Heidelberg
1944
Heide Park and Art Gallery, Melbourne
No.12

Making It New in Australia
Some Notes on Sunday and John Reed
Barrett Reid

'I have often been asked – by those who ask such questions – how we saw with such accuracy who were the important artists, and my only reply is that it was the most simple and natural thing in the world. One day there was nothing, and the next a miracle had happened. How could we not see it. I must, in fact, stress the phenomenon of that period, because I realize how hard it is for the younger generation, which experienced nothing of these years, to grasp the elementary fact that, for all intents, art – the creative product of the contemporary personality – did not exist. Prior to 1938–39 the whole atmosphere was one of stagnation and death, and to be able to share in the activity which so utterly and irrevocably changed this situation, was a truly beautiful and exciting experience. After the formation of the CAS things were never to be the same again'.

John Reed[1]

Innumerable the images
The register of birth and dying

Ern Malley[2]

For fifty years until their deaths in 1981, Sunday and John Reed played an historic role in the development not only of the arts in Australia, considered in their particularities, but in the creation of sensibility as a whole. They were among the notable pioneers of Australia as we know it today.

Their lives were so packed with activity yet essentially so private, so rich in human relationships yet mainly unrecorded, so fruitful and sometimes dramatic in impact upon the lives of others yet essentially so removed from the public domain, that it is difficult to provide a brief description of them without distortion. Their long and productive lives can be understood only against the quickly changing contexts of the fifty years during which Australia became, at last, a

country and a culture distinct from any other.

Both their families, the Reeds in Tasmania and the Baillieus in Melbourne, were long established and played significant roles in Australian history from colonial times. Though very different in style, both families were wealthy and, in the manner of their various times, possessed a cultivation and distinction above that usually prevailing in such Australian families.

John was born at Evandale, Tasmania, a pastoral property, in 1901, the grandson of the pioneer Henry Reed who left his native town of Doncaster, England, in 1826, to seek his fortune in Tasmania. Henry Reed quickly amassed a fortune as a merchant, pastoralist, shipowner and banker. Much of his time was given to evangelical Christianity and he financed charities and the building of many churches. Most unusually for his time, he was much concerned to protect the Aborigines.[3]

Henry Reed lived much of his later life in England, but at Launceston, Tasmania, he built the great house Mt. Pleasant which John's father eventually inherited and where John and his elder brother and four sisters spent much of their childhood. He has recorded that at the time he hardly noticed that the various Reed houses were hung with paintings including those of John Glover (1790–1868) whose paintings and those of his father are now regarded as notable examples of colonial art.[4]

John's especial delight as a child was in the bush, the wilderness and the mountains, and particularly in birds which he watched with a concentration and quiet forgetfulness of self. All his life he was a remarkable birdwatcher and,

unknowingly, he developed, in the need for stillness and accuracy of observation birdwatching demanded, and in a receptivity to the rare exotic unrecorded in official bird lists, a sensibility which was to serve him well when later he turned his eyes from birds to look at paintings.

John's ability to escape into the bush and the self-forgetfulness of bird watching protected him from the stuffy formality of family life at Mt. Pleasant. His youngest sister Cynthia found no such escape. In her first novel she wrote of her life there with something close to hate and all her life this graceful stone house was to her 'Mt. Unpleasant'.[5]

Sunday was born in Melbourne in 1905, the only daughter of Ethel and Arthur Baillieu. Her parents and her three brothers spent the happiest days of their childhood at Merthon, a beautiful sandstone house and large garden on the cliffs at Point King near the entrance to Port Phillip. One of Sunday's grandfathers, James Baillieu (1832–97), was the founder of a remarkable family whose activities were to be at the very centre of Australian financial history. His sons, especially Arthur's brother W. L. Baillieu, were to play historic roles in developing Australian industry. Their headquarters at Collins House, Melbourne, became from the Depression years to the 1950s, the central symbol of Australian capitalism. It is ironic that, for a time, John Reed had his legal office at Collins House and indeed ran the Contemporary Art Society from there. That situation soon became untenable, the cuckoo in the nest had soon to perch elsewhere, but for a time the communist artists and intellectuals made

great play of it.

Sunday's mother was unusually cultivated. She was an excellent amateur painter, a good pianist and her library with its collections of Katherine Mansfield and similar English writers of the time was quite extensive. The painter Sir Arthur Streeton was a family friend and his paintings, and those of others of the Heidelberg School, notably a magnificent McCubbin, *The Rabbiters*, were collected by Sunday's parents.

John's Australian childhood was abruptly and perhaps traumatically changed, when the family travelled to England to place him in Pinewood School (1911–12) and Cheltenham College (1913–14). He spoke of Cheltenham as 'ghastly and primitive',[6] much the same terms in which it was referred to by another Australian, Patrick White, who followed him there. He was 'only saved, after four years, by the First War. This resulted in six years at Geelong Grammar School (Victoria) followed by three beautiful years at Cambridge (Caius College) from which I emerged with a law degree and the sense of at least the freedom to be myself, something I had never known before.'[7]

Sunday's education was quite different. Her parents had her educated at home except for a few months at a Toorak girls' school. Her shyness was so extreme and her suffering so great that her parents had no choice but to keep her at home. One can still speculate on the creative and destructive aspects of this isolation from everyday life. She was a rare spirit who could not be caged and, in a long life, was never at ease with any social structures. Surprisingly she had many practical skills and an extensive, if

unordered, knowledge. Her family was a very loving one and its freedom and humour released her into a rare individuality which everyone who knew her found unforgettable.

At Cambridge John seems to have had little connection with the genius of the place. Later, his library contained most of Bertrand Russell's books but there is no clear evidence that he read Russell or Lowes Dickinson or Forster while he was at Cambridge. Lowes Dickinson's description in 1930 of the Cambridge outlook has, it seems to me, a particular relevance to John's personality:

> unworldly without being saintly, unambitious without being inactive, warmhearted without being sentimental. Through good report or ill such men work on, following the light of truth as they see it; able to be sceptical without being paralyzed; content to know what is knowable and to reserve judgement on what is not. The world could never be driven by such men, for the springs of action lie deep in ignorance and madness. But it is they who are the beacon in the tempest. . .[8]

His friends at Cambridge included Harold Abrahams who shared his passion for mountaineering. Abrahams later became famous as an Olympic runner. Other friends included Alf Rainbow who became an unorthodox judge in Sydney and who shared John's return passage to Australia via South America. Rainbow had a cursory interest in painting. Another friend, Robert Roberts, became a don at Corpus Christi and Dean of College in 1939. Like John he was a passionate naturalist and birdwatcher. After John

left Cambridge Roberts wrote to Australia a remarkable letter about the great loss his friends felt at John's departure and in which he described John as a hero out of Conrad.[9]

John and Sunday were married in 1932. He became a partner in Blake & Riggall, then Melbourne's leading law firm. A number of well-known artists were among their friends at the time but, surprisingly, none were part of the contemporary movement. Closest perhaps was Will Dyson, always called Bill, among a circle which included that successful exponent of a debased Streeton tradition, Harold Herbert, and Jimmy Bancks, the creator of Ginger Meggs, Australia's greatest comic strip. Looking back later John regarded himself at this time as 'hopelessly immature' and an example of delayed development.[10] The only art he had purchased of any note was a large wash drawing of a nude by Epstein called *Sunita* which he kept all his life and left to the National Gallery of Victoria.

Amongst this circle, however, was a young man who was to make a notable career as a designer, particularly of furniture, and it was Fred Ward who led Sunday and John towards modern art and the many notable adventures of the next fifty years. Of that half-century, this exhibition specifically relates to two activities in which the Reeds were central, the Melbourne publishing firm of Reed & Harris and the Contemporary Art Society. The CAS was founded in Melbourne in 1938 and *Angry Penguins*, the journal which led to the establishment of Reed & Harris, was founded in Adelaide by Max Harris in 1940. These events have been set in contexts variously described by Richard Haese as 'The

Revolutionary Years of Australian Art'; by Robert Hughes as 'The Angry Decade'. Max Harris has written of 'the Angry Eye'. Looking back at those years from the late 1930s to the early 1950s I see the flash and the fire of the avant-garde against a larger provincial canvas, a time I call the dusty years.

The Dusty Years

> I have heard them shout in the streets
> The chiliasms of the Socialist Reich
> And in the magazines I have read
> The Popular Front-to-Back
> But where I have lived
> Spain weeps in the gutters of Footscray
> Guernica is the ticking of the clock
>
> . . .
>
> It is something to be at last speaking
> Though in this No-Man's language
> appropriate
> Only to No-Man's-Land.
>
> Ern Malley[11]

. . . as it is the faith of the day, there are only a small number of people living who have achieved the right *not* to be Communists.

T. S. Eliot[12]

Many young painters and poets today, in Australia as elsewhere, are poor, very poor. It is accepted as the natural condition of the young artist. But the artists in this exhibition lived in a financial poverty of such an absolute kind it is hard to describe it to their young successors today. At this time there was no question of any of them being able to earn even a bare subsistence from their work.

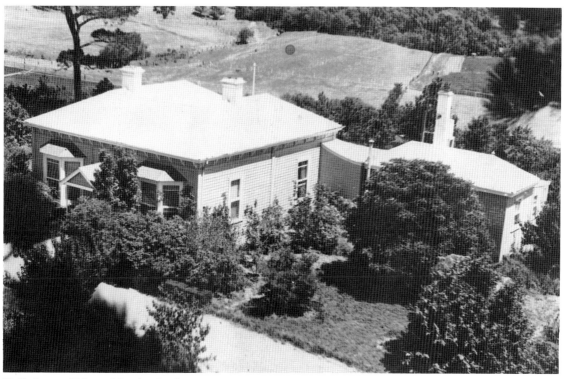

Heide, home of John and Sunday Reed

From the Depression to the first years of the War a conservative government, deeply dependent on England's financial imperatives, ruled the country. Set against the official rulers were the Australian Labor Party, the trade unions and a very small but growing Communist Party. Both rulers and opposition had little interest in intellect or imagination. The ruling culture was essentially provincial. That the working classes were alienated from it was a healthy recognition of its phony, second-hand quality; but, as yet, they had produced little in art or writing which could compare in quality with work coming from similar sources in older cultures. When the role of the artist was noticed at all by the opposition forces, and that was rarely, it was expected to serve a narrow nationalism, the bigoted nationalism of 'White Australia' and a pragmatic political purpose. Outside of these functions art was a suspicious and probably useless activity pandering to an élite.

'White Australia' was a place from which the creative spirit had fled. This is, of course, too sweeping a statement but even the universities and all major cultural institutions were dominated by an arid conservatism. On the one hand there was the 'cultural cringe'[13] of the established institutions and on the other, outside the established power centres, a strident and bigoted nationalism. They supported a philistine rejection of new directions in creative life which had emerged in other countries decades ago. Here in Australia these new directions were either unknown or dismissed contemptuously as:

'. . . the chatter of cultured apes
which is called civilisation over there'.[14]

So the artists in this exhibition lived not only in total financial poverty but in a poverty of the spirit provided by the prevailing culture. It is not surprising that the history of the questing imagination, or rather of the non-aboriginal imagination, in the years prior to this group of painters is largely a history of expatriates.

The first connections by Australian painters with the best painting of their own time, from the beginning of the century to the Angry Penguins years, were made by expatriate painters, and most closely and productively by those who spent their adult lives abroad, returning to Australia, if at all, only in old age. Australian art historians increasingly recognize this but much exploration is still to be done in defining the connections between the Australian expatriate painters and the modern art of their times.

The remarkable Rupert Bunny (1864–1947) spent forty-nine years abroad mainly in France. It is certain that he was inspired by French Impressionists, particularly Renoir, but any connection with Gauguin, strongly suggested in certain of his works, is not yet established. It is pleasing to note that in old age he did return to Melbourne and, in 1938, became one of the foundation Vice-Presidents of the Contemporary Art Society. The other was John Reed. The young Sidney Nolan paid a visit of homage to the elderly master. Both the young Nolan and the elderly Bunny lived in Melbourne in poverty, and in style. The record price, to date, for an Australian painting, $1.25 million, was paid for Bunny's *The Bathers*. Bunny died poor; Sir Sidney

Nolan, and other living painters in this exhibition, have found a proper, not to say, rich market. Australia *has* changed.

Bessie Gibson (1868–1961), a fine impressionist, duplicated the Bunny experience. Younger artists extended it: John Power (1891–1943) with the Cubists, Roy de Maistre (1894–1968) and Horace Brodzky (1885–1969) with Gaudier-Brzeska and the Vorticists. Sam Atyeo (b.1910) left Australia in 1936 and has lived in France ever since, making a few brief visits to Melbourne to see old friends like the Reeds. His friendships with Ossip Zadkine, Brancusi and others provided the Melbourne group, through the Reeds, with a palpable, if second-hand, connection with the French avant-garde in all its forms. These painters are only a few examples among many of the modern spirit in exile from Australia.

Atyeo was a protégé of Dr H. V. Evatt, a scholarly writer and High Court Judge (1930–40), later a leader of the Australian Labor Party and foundation president of the General Assembly of the United Nations. 'Bert' and Mary Alice Evatt collected Picassos, a very fine Modigliani, an important Juan Gris, and works by Vlaminck and Léger. Their friendship with Cynthia Reed, John's youngest sister, and with John and Sunday began at an exhibition of Atyeo's paintings given in 1933 by Cynthia Reed at her Modern Furniture shop in Melbourne. Evatt became a lifelong friend of Sunday and John and appeared at highly significant moments in their long championship of modern painting.

The painters in this exhibition are painters of a transition. Like their predecessors the

expatriates, many dreamed of living in an older and richer culture and to escape perhaps from the battles yet to be fought here which were arid and to them unnecessary. But these battles had to be fought and the Reeds, Max Harris and the artists of this exhibition were all, willingly (and a few reluctantly) to become engaged in them.

In 1939 Sir Keith Murdoch of the Melbourne newspaper *The Herald* brought to Australia an exhibition of French and British contemporary art, an enormous exhibition mainly of Post-Impressionists – there were seven important Cézannes – but its impressive range extended from the Post-Impressionists to nine Picassos and on to the Surrealists such as Ernst and Dali.

John Reed initiated a campaign to collect a fund to purchase works for national collections. J. S. MacDonald, the Director of Australia's premier art institution the National Gallery of Victoria, opposed the suggestion in characteristically vehement terms: '. . . if we take a part in refusing to pollute our gallery with this filth we shall render a service to art'.[15] When the exhibition was kept in Sydney by the outbreak of World War II the trustees of the National Gallery there, after the initial showing, refused to exhibit the paintings and sculptures further and they were hidden, dark forbidden fruit, in the basement. Only minor works were purchased for the Sydney and Melbourne permanent collections.

The whole career of J. S. MacDonald, as art critic and then as head of our leading gallery, now reads as if invented by Evelyn Waugh at his mordant best. Indeed MacDonald can be seen now as screamingly funny. But it is not amusing

that Australia lost the chance to acquire a range of masterpieces today forever beyond reach.

In a way John Reed rather enjoyed Jimmy MacDonald; his trenchant conservatism had a kind of zany integrity and, John thought, could only strengthen the avant-garde's position. Other and more subtle 'liberal' successors became much more effective taste-makers and 'in immediate terms we were beaten all along the line'.[16]

The *Herald* exhibition remains the most important exhibition in relation to modernism in the history of art in Australia. It brought Tucker, Nolan and others physically in touch with work they had known only in reproductions and through the prints, books and conversation of a remarkable Italian, Gino Nibbi, who owned the Leonardo bookshop and print gallery in Melbourne. Meeting so many of the icons of the School of Paris face to face was vital. The culture the exhibition represented had, however, already unknowingly sent its ambassadors ahead. Albert Tucker has said that meeting Danila Vassilieff and Yosl Bergner 'gave me confidence'. They 'both had an acceptance of themselves as artists' whereas to disclose himself as a fully committed artist to most of the people Tucker knew 'immediately put one in queer street'.[17]

As usual it is Tucker who most clearly sums up a central crisis for the painters of his time and place: '. . . we had a kind of cultural schizophrenia in which we would alternate between fantasy and reality. At times Australia was reality and Europe was fantasy; and then when you felt the pressure from events, or books or paintings, Europe would suddenly become the reality and Australia would become the fantasy.'[18]

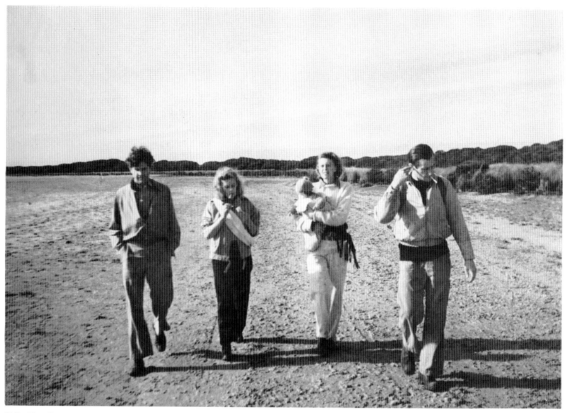

John Reed, Joy Hester, Sunday Reed (with Sweeney, son of Joy Hester and Albert Tucker) and Sidney Nolan at Point Lonsdale, c. 1946

Nolan dreamed of the Champs Elysées. At Heide he said to the young writer Michael Keon – who left Australia during the War and lived in Europe, America and Asia for the next thirty years or so – ' "They will be the Fields of Heaven for us, you'll see!" (with a slyish glance to check if my French was up to his) . . .'[19]

Joy Hester, who first met Sunday Reed at the *Herald* exhibition, felt less of the tug of Europe than the others:

> I am quite reactionary about Aussies travelling. Why, we've only been here a hundred years. What can be added by going before we are here? – that is not right for we

are here but only just here. If we don't hold what we have we may never find it again, so delicate a thing it is, yet it gives the impression of being over-powerful on close examination . . . I don't think a change of location can answer our questions.[20]

Ironically, Joy was the only one among these artists who never in her work dealt with the Australian landscape. Her drawings essentially are concerned with human identity and, by extension, the question of whether one is or is not 'Australian' is a part of that concern.

It could be said that Joy, in any case, had little chance to leave Australia. Her first child was

born in 1945; she was to have two more children and to live in a house John and Sunday purchased for them. But whether to leave Australia or not was a question which Joy, the Reeds and most of their friends discussed. For all their lives the Reeds felt a strong attraction to the idea of living in Europe – on the face of it there was little to stop them. That they did not do so was a conscious decision thoroughly debated and thought out in their characteristic way. Their friends, however, increasingly left Melbourne, and while other younger creative spirits arrived to create around the Reeds a vibrant life right up to the very end of their lives, the letters of the time reveal the enormous sense of loss they felt when their friends of these years left Melbourne and *Angry Penguins* ceased and the Contemporary Art Society went silent for a time.

At the close of the dusty years Albert Tucker was off to Japan and then, with the continuing financial support of the Reeds, to Europe and America. As he left in 1947 he said, in a farewell much quoted subsequently, 'I am a refugee from Australian culture'.[21] He was to remain abroad until a grant from John Reed's Museum of Modern Art enabled him and his paintings to return in 1960.

Poverty and the War had concentrated an energy in Melbourne. It was an energy pushed together by a hostile population which had already dispersed Australia's greatest artists, the Aboriginals, to the furthest fringes. It had excluded all but a very few remarkable women from serious consideration. It was an energy cross-fertilized by Europeans escaping totalitarianism and then by a very few Americans

among the US forces. The dusty years blanketed their impact and it was only a minority, such as the Boyds and the Reeds and some elements of the Communist Party, which benefited. One famous shipload of European anti-fascists and Jews were immediately interned! It included many who much later were to become leaders in a more civilized Australia. Amongst the American forces were a few great jazz musicians, intellectuals and poets such as Karl Shapiro and Harry Roskolenko, who were to provide *Angry Penguins* with fruitful contacts with some of the liveliest people in American cultural life.

From 1947 the dispersal of this energy, its anger, its need for change, had begun. From 1950 Nolan has lived in England, returning frequently to Australia to continue his travels throughout the country, as indeed he obsessively travels the world. Arthur Boyd has continued a family tradition of generations, living partly in England, partly in Australia. Perceval left Melbourne for London in 1962 where he and his family lived for three years. Since then he has lived in Melbourne. Max Harris also spent some years in England but then settled firmly in his native South Australia. Alister Kershaw, a poet whose second book *Excellent Stranger* (1944) was published by Reed & Harris with a cover by Albert Tucker, has spent his life in France. In 1950 Yosl Bergner migrated to Israel. There his style changed radically and he is now a leading Israeli modernist. Noel Counihan lived and died in Melbourne but, after the War, he too became an inveterate traveller spending some of the most fruitful years for his art in a French village.

How different was the world of the artist

then, the dusty years, to that of the creative Australians of today. Those today feel quite differently from the expatriate Rupert Bunny and the unsettled Nolan and Boyd.

Today our writers and painters, at least on a broad view, are not self-consciously Australian. Most of them seem to prefer to live here and to take part in the everyday exchanges of a vigorous culture but they, and their works, range much more freely around the world. Novelists such as Peter Carey often prefer to publish first in Australia, but editions soon follow in New York and London. To live in Tuscany or Toronto is not seen as making any particular point, or certainly not a simple one, about an Australian audience. If David Malouf spends some of his time in Italy it is mainly in the nature of a retreat so that he can get on with his fictions undisturbed. Another fine novelist, Elizabeth Jolley, has spoken of the strength she gathers from living in Western Australia and her writing appears as a matter of course in American editions and her articles in *The New York Review of Books*. Our film-makers commute regularly between here and Hollywood and other centres.

Artists from many countries now come to live for a time in Australia. The notion, perhaps always dubious, of a 'mainstream' of contemporary expression running out of some, perhaps always merely symbolic, 'metropolitan' centre, a notion which the painters of this exhibition shared to a greater or lesser degree, is over. And the Aboriginal artists are at last finding a large audience and appearing not in the anthropological museums, but in contemporary sections of all our major collections.

The dusty years have long since gone. Two of the central forces which laid the dust and created a free-er air were the Contemporary Art Society and Angry Penguins, in both of which Sunday and John Reed played decisive parts.

The Contemporary Art Society

The promise of a new architecture
Of more sensitive pride

Ern Malley[22]

From the mid 1930s the Reeds moved to the centre of the fight against the establishment of many fronts of prescriptive programmes for art. While each artist had necessarily to develop a personal programme the Reeds developed a view which they made explicit over and over again until the very end of their lives: you need to come to all new expression unshielded by dogma, to regard experience as not susceptible completely to rational explanation and, in any event, logic itself was an evolving process. Art, like every other part of human experience, was a mystery. One could report on one's experience certainly, and John Reed in particular reported with reason, and a simple lucidity, but one brought to the first experience all one's resources of which knowledge and thought were integrated parts of a larger whole. They were suspicious of those who had all the answers.

In the period which produced the work in this exhibition there were, of the attempts to prescribe art before the fact of its production, three which were especially notable. John and Sunday Reed were central to the struggle against all three. They would be the first to point out

that, in each case, they were following closely where particular artists led, but if one sees the three events as a whole, the Reeds' attitude stands out as immediate, consistent and thorough in following through and living out the consequences.

The first attempt to establish explicit standards was the proposal by R. G. Menzies in 1937 to form an Australian Academy, in imitation of the English Royal Academy, to give formal status to the prevailing canon of taste. Menzies was then Attorney-General of the Federal Government, later to become Prime Minister for many years. In his political role his personal interventions in official art and literary institutions were to continue throughout his long career.

George Bell, a Melbourne painter and influential teacher of art, forcefully led the fight against the Academy. He was aided by others including John Reed and Reed's friend Dr. H. V. Evatt. Bell's instrument was the Contemporary Art Society which he founded in 1938. John Reed became a vice-president and drew up the constitution. The first exhibition of the new society was opened in 1939 by H. V. Evatt. This and subsequent annual exhibitions created a highly satisfactory uproar and drew huge audiences. John Reed, then thirty-eight, played the most vigorous role in ensuring that art moved off the social pages and became a matter of wider public interest and debate. At this time Danila Vassilieff was forty-one, Noel Counihan twenty-five, Albert Tucker twenty-four, Sidney Nolan twenty-two, Vic O'Connor twenty-one, Yosl Bergner, Arthur Boyd and Joy Hester were

nineteen, and John Perceval was sixteen. Max Harris was eighteen and soon to publish his first book.

The second attempt at prescription came from within the CAS. George Bell and his supporters attempted to create a selection committee for exhibitions which, if George Bell and his friends were to control selection, would have effectively confined exhibits to pale derivations of the Post-Impressionists, particularly Cézanne. A case of *Degas vu*. Reed had long argued that any attempt to define taste in explicit terms, to create for the mystery of art a reasoned structure to contain it all, was both art- and self-defeating. To him all standards were arbitrary, prisons of time and place, and to erect them without an open door was to put free expression in gaol.

Nolan's *Portrait of Rimbaud* (1938–9) became the symbolic prisoner. Bell rejected it from the inaugural CAS exhibition. Reed immediately and successfully protested:

> I argued that the CAS must be the one place where the artist was 'free'; that no one, artist or otherwise, could tell him what he should or should not exhibit and that the responsibility for this was his and his alone.[23]

Reed's success in keeping the prison door of certain taste from being closed upon *Portrait of Rimbaud* led eventually to the resignation of George Bell and about sixty members, the only members with any public standing. But the CAS continued to have exhibitions which, in terms of the crowds they drew and the fierce debates they occasioned, were highly successful. (But not, of

course, in terms of sales.) The exhibitions left no doubt that modern art had arrived in Australia. Some saw it as an exotic transplanted into an alien clime – and there were examples to support this view; a very few saw the emergence of new species; the whole spectrum of the School of Paris, German Expressionism, even perhaps Malevich, had fertilized inspirations which were native to this particular time and place.

The third attempt at prescription, that is, to impose a reasoned and particular view of art upon the young talents emerging in the CAS, came from an attempt by communist artists within the CAS to capture control and to give direction to its members. Harry de Hartog, Noel Counihan and Yosl Bergner were then communists and were essentially carrying out the cultural policy of the Communist Party as laid down by A. A. Zdhanov for Stalin and adopted without deviation by their comrades in Australia.

The resulting debate was strenuous and much of it can be found in the pages of *Angry Penguins*. Albert Tucker rose to the occasion magnificently and in a series of articles debated the issue with the communists whose articles were also published in the magazine. They are now seen as key documents of our cultural history.

In the first of his articles 'Art, Myth and Society' he attacked with a trenchant polemic and a reasoned power of language, rare anywhere and particularly amongst painters:

> The moralist has returned to art, this time a political moralist bent on making art conform . . . By denying the validity of artistic perception, left politicians debase art by

demanding forms which are accessible to the widest mass of the people – a people whose aesthetic sense has been corrupted and stunted by decades of living under monopoly capitalism . . . The communist slogan for art has been: Take art to the people. I would say: Take the people to art.

On the communist side many of the polemics became personal attacks of the most scurrilous kind. While the pages of *Angry Penguins* were open to all sides of the debate, the communist press refused to print letters in reply by Tucker, John Reed and others. A prominent party member stated that 'In Russia the party press does not grant a right of reply to fascists. It is the same here'.[24]

One major and, in the long view, highly destructive effect of this debate was the alienation it produced between the *Angry Penguins* group and Bernard Smith who was to become Australia's most distinguished and productive art historian. His long list of works range outside his particular discipline and have gained him a place in Australian literature.

In 1944 Bernard Smith was a young Sydney teacher and intellectual. He published poems, one of them in *Angry Penguins*, and was an editor of the annual anthology *Australian New Writing* (1943–6). At the time of this debate he was writing his first important work, *Place, Taste and Tradition; A Study of Australian Art since 1788*, which he published in 1945.

Bernard Smith allied himself to the communist artists and an unfortunate consequence, with long term effects on generations of Australian students, was that *Place,*

Taste and Tradition gave a quite inadequate response, indeed sometimes unjustifiable dismissal, to the *Angry Penguins* painters. 'Today', he wrote, 'there is a Nazi flag flying from the top of the ivory tower . . . Today the most vigorous supporters of aestheticism are either openly Fascist or near Fascist in their political opinions'.[25]

Joy Hester, whose drawing had been published in *Angry Penguins*, was not mentioned at all. The destructive effect of this book on the understanding of the emergence of new strengths in the work of Vassilieff, Boyd, Tucker, Nolan and Perceval was a powerful factor in keeping appreciation of their new directions to a small group. Space allows only one specific example. *Place, Taste and Tradition* devoted one paragraph only to the work of John Perceval. *Angry Penguins* had given a full page reproduction to Perceval's *Boy with a cat No. 2* (1943) and John Reed had written an article on Perceval's work at that time, saying that it contained 'a certain guarantee of future development'. Of *Boy with a cat* Reed wrote that it showed a 'heightening of sensibility and an increase in acuteness of observation, and a developed power for concentrating emotional and visual experience'.[26]

Neither then nor later did Reed's articles and introductions to the *Angry Penguins* painters make any noticeable impact on Bernard Smith. Smith wrote that these paintings of Perceval's provided 'clear enough evidence that regression to a purely individualistic art has not resulted in the heightening of his artistic powers up to the present moment'.[27] *Boy with a cat* is now one of the glories of the national collection. In 1945

Perceval was twenty-two and there were few to welcome and encourage a major talent at a vulnerable stage.

Perceval's sense of his worth became uncertain. He painted over certain paintings. In recent years some important works have had to be separated from the backs of others. *Boy with a cat*, like so much else in this exhibition, came home to Heide.

The CAS, mainly through John Reed's vigour, had expanded from a Melbourne organization to include autonomous branches in Adelaide, established with the help of the young Max Harris, and in Sydney where a Melbourne family friend of Sunday and John, Peter Bellew, was to be the founder. Bellew was not only to be a vital spark in the proceedings of the Sydney branch but to transform, as editor, the last six issues of *Art in Australia* (1939–42) from a long-established and stodgy frump into an extraordinary journal hospitable to the avant-garde both of Europe and of the *Angry Penguins* group. In colour, quality and design Bellew's *Art in Australia* resembled *Verve* or *Cahiers d'Art*.

The CAS 1944 annual exhibition was the last of the great exhibitions where the works of artists of so many different kinds and from all branches were brought together. A decided divergence of taste developed between the Angry Penguins painters in Melbourne and that of the Sydney painters favoured by the German-born Sydney painter and critic Paul Haefliger (1914–82) and whose work was championed in the books and journals of the amiable and undisturbing Sydney Ure Smith. Some of the painters favoured by Haefliger and Ure Smith have been labelled 'the

charm school',[28] a catchy phrase which touches on something central to their aspirations but ignores the paintings which escaped from that limitation; it also, by excluding the sunny aspects and exuberance to be found in Vassilieff, Nolan and Perceval, provides a false dichotomy between the painters of Sydney and Melbourne. The CAS Melbourne exhibitions continued annually until 1947 and then stopped until a new group joined with Sunday and John Reed to begin anew in 1953.

Angry Penguins and Reed & Harris

> . . . renew the language. Nero
> And the botched tribe of imperial poets
> burn
> Like the rafters. The new men are cool
> as spreading fern.
>
> <div align="right">Ern Malley[29]</div>

The nine issues of *Angry Penguins* (1940–6) and the ten issues of *Angry Penguins Broadsheet* (1946) still can astonish us today. What is remarkable is not only the range of contributors from within Australia and abroad with a great variety of styles and attitudes but the openness to a series of ideas often in fierce conflict. The ideologies ranged from communism to liberal socialism, from anarchist to iconoclast; there was room even for the dandy mandarin with contempt for all these houses.

Angry Penguins was founded in Adelaide as an undergraduate magazine by the nineteen-year-old poet and intellectual Max Harris. His interest at that time in Australian history and the writing and painting of older generations was minimal.

On the one hand this gave his comments on the culture around him a freshness and a larrikin verve, on the other it caused a serious dislocation in his lack of recognition that modern poetry had begun in Australia elsewhere and earlier, particularly in the work of Kenneth Slessor (1901–71), who had quietly assimilated the influence of Pound and Eliot. This was evident even earlier than 1939 when Slessor published his masterpiece *Five Bells*. Max, also, because of his youth, isolation in Adelaide and an intensely focused attention on the masters of European modernism, was at that time strangely insensitive to the contemporary emergence from 1940 onwards of Judith Wright (b.1915), Australia's greatest poet since Slessor. He was ignorant too of the importance of Max Dupain, a photographer who had developed from European modernism a series of remarkable works from 1935 or earlier.

Harris and John Reed came together in extending CAS activities to Adelaide, and the Reeds' influence is graphically shown by the abrupt change in content and presentation of the fourth issue when John Reed became a contributing editor. While the Reeds brought a knowledge of modern painting and a generally more mature judgement to the journal, it is still true that they kept their habitual position of 'following the artist' and placed their energies and resources totally behind the young poet intent on capturing the leadership of his generation. The contribution of the young poet to an avant-garde which cut across the demarcations of the arts and also across the usually separate worlds of specialist intellectual activity was the single most precipitating factor of

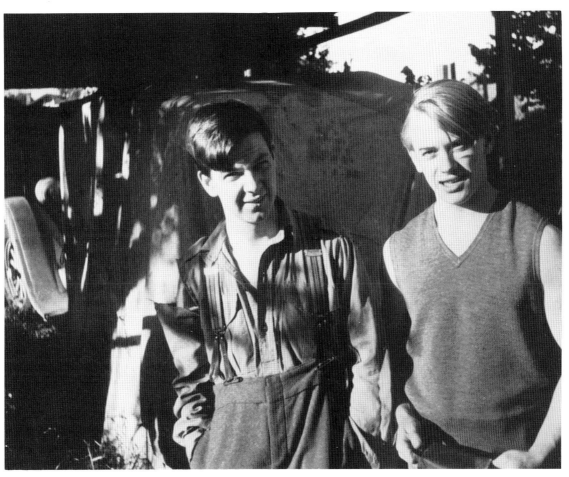

Arthur Boyd and John Perceval outside the Boyd's family home in Murrumbeena, c. 1945

the whole enterprise.

Together they established in Melbourne the publishing firm of Reed & Harris. The partners were Sunday and John Reed, Max Harris and Sidney Nolan. They were to publish not only the two journals but a wide-ranging list of books and a news magazine *Tomorrow* which attacked with considerable wit the prevailing Australian power structures. The whole activity was financed by Sunday and John Reed and it strained their financial resources to the limit and beyond.

Their financial support of particular artists such as Nolan, Tucker and Perceval continued. Richard Haese has written of the young Perceval calling at the Reed & Harris office to pick up his £1 a week.[30] It is not uncommon for people with 'independent incomes' to have the extent of their wealth romantically exaggerated by poverty-stricken friends. The Reeds had few of the luxuries of the rich in their daily lives. At Heide they shared together the housework in their weather-board cottage and on their fifteen acres

41

worked to a strict regime, milking two cows, making an ever-expanding garden which included an indispensable kitchen garden, and planting and maintaining an orchard. By then John Reed had left his law practice to devote his energies to the CAS, to Heide and to the publishing firm. The demands on the Reeds' resources, human and financial, were endless and when, as inevitably happened, they sometimes could not meet these demands a bitterness and even a hatred met them and marked their lives.

Most commentators to date have concentrated their comments about Reed & Harris on the writings of Max Harris, the poems of the mythical Ern Malley, and the work of the artists represented in this exhibition. These notes must attempt to redress this imbalance while avoiding if possible mere lists of names. Among important Australian writers published by the firm at the very beginning of their careers were the novelist and master of the short story Peter Cowan, Alan Marshall, the poet Geoffrey Dutton, Hal Porter and the young Sydney intellectual Donald Horne who was to have a brilliant future. *Angry Penguins* also published a long article by Leonhard Adam on the art of the Australian Aborigines which pioneered an aesthetic rather than an anthropological approach. And it is refreshing to note that the firm sought out and masterminded the delightful memoirs of Australia's great vaudevillian 'Mo', Roy Rene, undoubtedly a genius and our greatest comic talent prior to Barry Humphries. (It is not surprising that much later John Reed was to open Barry Humphries' first exhibition.)

Another strand in Reed & Harris is worth

particular attention. They published many of the liveliest talents of other countries. Henry Miller's book *Murder the Murderer* was published by Reed & Harris because Miller could find no wartime publisher in England or America brave enough to face censorship. In *Angry Penguins* (the 1945 issue had grown to 184 large pages) and in *Angry Penguins Broadsheet* were found not only translations of Rimbaud, Lorca and Rilke, but new poems by Dylan Thomas, Kenneth Rexroth, Robert Penn Warren and work by two newcomers, James Dickey and García Márquez, who were not to become generally known, even in their own countries, for another twenty years.

It was in *Angry Penguins* that I first came across the art criticism of Sidney Janis (*Abstract and Surrealist Art in America*) and the political philosophy of Sidney Hook.

Albert Tucker, to great effect, had joined the magazine as editor of a sociology section. There was a section devoted to contemporary music from jazz to Shostakovich where the important Australian composer Dorian Le Gallienne also appeared. There was a striking attempt to attract outstanding new talent from New Zealand and in this way Greville Texidor, whose fiction has this year been rediscovered and republished in New Zealand, Frank Sargeson, Kendrick Smithyman and other notable New Zealand voices were introduced.

The editorials which introduced *Angry Penguins* have certain stylistic characteristics of John Reed's prose. But letters flowed between Harris and Reed, at times almost daily, and no doubt the editorials reflected both their views and sometimes resulted in some muddled or

conflicting passages. *Angry Penguins* had been intended to be a quarterly, but the firm did not have the paper licence required in wartime and was forced to many shifts and strategems including printing on paper of the poorest quality. Accepted contributions grew alarmingly as the search for paper went on. The issue for 1945 was printed on the nastiest newsprint but one can still remark on the magazine's excellent design. Sidney Nolan led the design effort. Excerpts from the editorial give the reader a description of the journal as it had evolved and the growth of a view that not only the influences of an international avant-garde had to be assimilated but that a specifically Australian expression had to evolve:

> The growth of *Angry Penguins* has been, we believe, of an organic character. To start with, an eclectic anthology for verse, then including prose, subsequently widening its scope to cover the field of painting, and latterly embracing music, the film, and finally sociology. We do not feel that this growth has been forced, but rather has come about by a natural process indicated by a deepening awareness of the wide integrations of art with society and the necessity to provide an over-all cultural organ for the artists of this country.[31]

The editors turned their eyes abroad noting the arrest of Ezra Pound and the collaboration with the Nazis by some French artists:

> It would be false to pretend that these things do not affect us, that this isn't France, and that accordingly we must pursue our own 'pure' course uncorrupted by the passions

engendered in countries over-run by the Nazi armies. These things do affect us and affect us vitally, and our duty and our function is, not to ignore them, but to see them in a proper perspective.[32]

All of the artists in this exhibition had works reproduced in *Angry Penguins* and often the first commentaries on their work appeared there. All were conscious of the need to 'break through to something . . . that will belong'.[33] Richard Haese in his seminal work quotes Arthur Boyd and Boyd's words reflect as well as any the aspirations of all these painters, painters who never saw themselves as sharing a common purpose, but certainly as sharing a common hope:

> There was a feeling that there was a group of people working who were doing much more original work than was being done anywhere else because the War had depleted Europe . . . You had the feeling that, well, perhaps it was not impossible to have something that could be original – and it was good to be part of it.[34]

Ern Malley

Sting them, sting them my Anopheles

Ern Malley[35]

It seemed we had substituted
The abattoirs for the guillotine

Ern Malley[36]

As the world knows, the Malley poems were a hoax. They were written by two poets, James McAuley (1917–76) and Harold Stewart (b.1916).

Their intention was conceived as a serious literary experiment to draw attention to the decadence of modernist values and to 'the gradual decay of meaning and craftsmanship in poetry'. There were sixteen poems purportedly written in one afternoon with the aid of quotations from any books which happened to be in reach: Shakespeare, a dictionary of quotations, an American report on swamp drainage. 'We opened books at random, choosing a word or a phrase haphazardly. We made lists of these and wove them into nonsensical sentences'.[37]

They invented a biography for Ern who was said to be a garage mechanic who later peddled insurance in Melbourne and died of Grave's disease at the age of twenty-five. The only book he was known to have possessed was Veblen's *Theory of the Leisure Classes*. They invented an uneducated sister Ethel who sent the manuscripts, *The Darkening Ecliptic*, to Max Harris. Harris was convinced that Malley was 'one of the most outstanding poets we have produced here'.

When Max had first shown the Malley manuscript to his partners at Reed & Harris, Sunday had initially wondered whether Ern Malley was the mask of some other poet, possibly Alister Kershaw. Kershaw had written a scathing satire on a number of his contemporaries including some of the Reed & Harris group. With characteristic open-mindedness *Angry Penguins* published Alister's satire, *The Denunciad*. This quotation gives the flavour:

> Around about the 'Angry Penguins' play,
> Cheerfully woeful or morosely gay,
> Pleased but uncomfortable that they are
> free

From class rooms in their university,
For none can break the umbilical chords
Which join these poets to their mortar
 boards.
Mostly they quit their academic kind
Only for Alma Maters of the mind
Where John Reed, dressed the professorial
 part,
Hears them their lessons in the school of
 art,
Where Sidney Nolan, like a looney don,
Shows them the canvases he's painted on
Or – if his art must rightly be defined –
His blobs of paint with canvases behind;
Or yet again, where Albert Tucker reels
Towards the blackboard of his high ideals
On which dull surface he has often placed
In crimson chalk the proof of his low taste;
Tucker who, like a cultured cockroach, lives
Deep in the cleft of split infinitives . . .
A point about these pleasant little birds
Is that their *only* being lies in *words*.[38]

The partners elected to follow Max's judgement and to back it to the hilt. The whole of Ern's work was reproduced in a number of the magazine dedicated to him and Sidney Nolan produced for the cover one of his most beautiful and lyrical paintings, incorporating in it some lines from Malley: *Arabian Tree* (1943). Max Harris surrounded Ern's work with a mass of his own poetry and prose in homage to his discovery.

After the magazine had been distributed a Sydney newspaper revealed the hoax. Telephoned in Adelaide at 3 am, a sleepy Max Harris managed remarkably well in the circumstances: 'The myth is sometimes greater

Angry Penguins

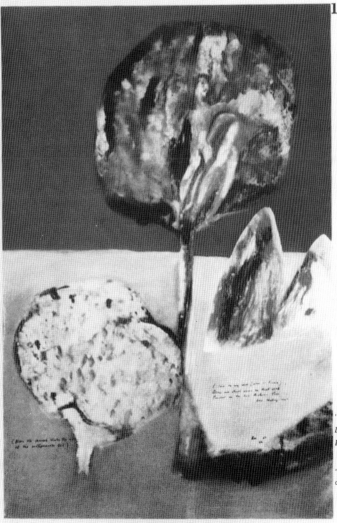

1944 Autumn Number
to Commemorate
the
Australian
Poet

Ern Malley

"I said to my love (who is living)
Dear we shall never be that verb
Perched on the sole Arabian Tree"

"(Here the peacock blinks the eyes
of his multipennate tail.)"

Painting by Sidney Nolan.

Front cover of the 'Ern Malley' issue of **Angry Penguins**, *1944*

than its creators'.[39] His partners rushed to his support. The news engaged the attention of the world's press, items appeared in *The Times*, London, *Time Magazine*, New York, and all the Australian press. Ern was suddenly the best-known poet Australia had produced although his actual verses were rarely quoted. It was a field day for the philistines. John, with the total support of Max, reacted quickly and vigorously. All serious contributions to the debate must be published in the magazine as intelligent discussion was notably absent elsewhere, and in addition Ern's poems were to be produced as a separate book, as finely designed and printed as wartime conditions would allow. Two editions were produced and quickly sold out.

The social realists, the liberals and the conservatives of the culture spectrum were all exultant. All that Reed & Harris stood for was, they thought, discredited. Few came to their defence, a notable exception being Herbert Read whose books had long been a major influence on the *Angry Penguins* group. Read cabled support and followed the cable with a long statement:

> It comes to this: if a man of sensibility, in a mood of despair or hatred, or even from a perverted sense of humour, sets out to fake works of the imagination, then *if he is to be convincing* he must use the poetic facilities. If he uses these facilities to good effect, he ends up deceiving himself. So the fakers of Ern Malley.[40]

Since then the poems have been re-issued in numerous editions.

It was a time of incredible speed and pressure. Suddenly while the controversy was still raging came a blow which would test everyone and reveal all the elements of Australian culture in sharp focus.

Max Harris, who had returned to Adelaide, was there charged by Detective Sergeant Vogelsang with publishing in the Ern Malley issue of *Angry Penguins* material which was indecent, immoral or obscene.

In 1944 censorship in Australia was indeed powerful. Books by James Joyce, Henry Miller and a thousand others were banned. Robert Close was about to be gaoled for his novel *Love me Sailor*, Glassop's war novel *We Were the Rats* had been banned and William Dobell was shortly to be involved in litigation brought by conservative painters who denied that his *Portrait of Joshua Smith* could rightly be awarded the Archibald Prize for portraiture. The Archibald was then Australia's leading art award.

Judgement on art was being made in the courts. John Reed immediately took a major role in Max's defence, arranging not only legal representation but finance and the marshalling of witnesses. He contacted all leading cultural organizations and individuals pointing out that an essential element of civilization, freedom of expression, was under attack. He worked tirelessly to ensure that as many as possible realized that when the twenty-three-year-old Max Harris stood in the dock our civil liberties stood with him.

The responses to his letters are interesting and, mainly, sad. George Bell refused to help in any way. The Communist Party, organizations associated with it and the communist artists were either silent or openly on the side of the police. A

very few older writers of the liberal tradition, such as Vance Palmer, offered Reed their support. The amount collected for the defence fund was derisory.

J. I. M. Stewart was then Professor of English Literature at Adelaide University. In his recent memoirs he has revealed how powerful were the forces ranged against Harris. A very senior judge (connected with the University) strongly advised him (warned him?) not to appear for the defence. Stewart appeared. It is a striking instance of how deeply *Angry Penguins* had offended established powers and prevailing ideologies. If civilized Australia stood in the dock in Adelaide it had few citizens.

For two and a half days the young poet replied to cross-examination, calmly and cogently defining an aesthetic, explaining imagery. It was a curious situation. Philistine Australia including a majority of intellectuals had agreed that the poems were nonsense. At the same time the prosecution, which was its symbolic voice, argued that the poems made sense enough either to be indecent, immoral or obscene.

And they had their squalid triumph. Max was found guilty of indecent publication and was fined £5 with the alternative of twelve weeks in prison. John and Sunday went heavily into overdraft and paid the bulk of the legal expenses. In the four decades I knew them I never heard them mention this or indeed only one or two isolated instances of their financial support to any person or to any cause.

Now we can see that a major victory grew out of this defeat. For another decade or so there were to be other similar prosecutions of painters

and writers, prosecutions in Sydney and in Melbourne where, with many others, John Reed and I came into court for the defence. But the march to freedom for the arts which is so natural in Australia today began its final journey when Max was summoned to court.

Heide. Sunday and John

> One moment of daylight let me have
> Like a white arm thrust
> Out of the dark and self-denying wave
>
> Ern Malley[41]

When I first heard of the activities of the CAS and read my first issues of *Angry Penguins* and books published by Reed & Harris I was a youngster in Queensland. Melbourne seemed the place to be. I was to have poems published in *Angry Penguins*, first in the Ern Malley issue, when I was sixteen. In romantic excitement I imagined the editors and the artists in all the wild and woolly colours of Bohemia. The letters which flew back and forth should have moderated that view. From both Max and John I got encouragement certainly, but also tightly reasoned, disciplined and tough strictures.

Before I could get to Melbourne Sunday and John came to Brisbane. They had taken a holiday after the Malley affair and the follow-up issue of *Angry Penguins*. I went to the Carlton Hotel to take them out to dinner. I waited in the lobby anxiously glancing at the lift for the wild ones of my imagination. My gaze turned to the staircase and there, arm in arm, walking quietly down were two very beautiful people. Good heavens, I thought, they're *respectable*. I could have taken

47

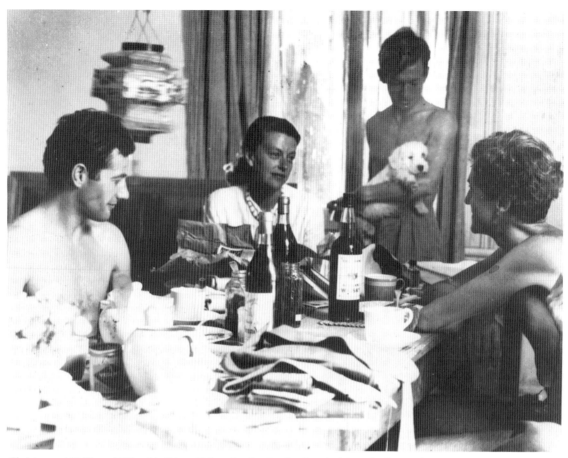

Christmas at Heide, c. 1945, with Sidney Nolan, Sunday Reed, John Sinclair and John Reed

them home to my (almost) nineteenth-century father.

It was hard to reconcile that quietness and grace, that shy but unaffected charm, with the open delight with which they responded to my plans for the evening's adventures. I offered a hasty revision. Indeed not. It would be fine to 'just be yourself and do what you usually do'.

Not long after that meeting the young painter Laurence Hope and I hitch-hiked to Melbourne. There were wartime restrictions on travel so we, with others such as Charles

Osborne and Charles Blackman, were to hit the road many times. Alas it was not us but Kerouac who, much later, made literature out of such country crossings.

When we arrived in Melbourne we went straight to the offices of Reed & Harris in Queen Street. We had travelled in the Christmas holidays of 1946. The first people we saw in the office were Albert Tucker and the American poet Harry Roskolenko. With one glance Bert summed up the situation: 'You're too late', he said, 'it's all over'.

Bert was about right but there were a few explosions yet to come. Nolan put me up in his studio. On the end wall was *Kiata* (1943). My encounter with it was stunning. It completely altered my way of looking at the sky and the distance I so often travelled: it showed me an art which was new but essentially part of my own landscape.

We took the train out to Heidelberg. At that time the Melbourne suburbs ended there, and we walked a mile and crossed a bridge and came to Sunday and John's house through a garden with fruit trees, lavender hedges, and the richest scents of a country summer. The name of their house began as a joke on the Australian habit of turning everything into its diminutive. Christmas becomes Chrissy, football becomes footy, Heidelberg becomes Heide. Somehow the joke became a name but I like to think the grin and the put-down are still here.

Heide had fifteen acres of garden and farm paddocks sloping down to that part of the Yarra River where the painters of the 1890s, Conder, Streeton and company, had often painted. It was a nice thought, reinforced by the Streeton and the McCubbin hung in the weatherboard farmhouse. Today the suburbs stretch far past Heide. Now it sits in almost an inner suburb. But the huge black cockatoo still sweeps among the black wattles by the river and the large and the small wattle birds make their wooden clacks, and the eastern rosellas make their rainbows as they have done forever.

Nolan was completing the first *Ned Kelly* series in the Heide dining room. I wrote of that first visit:

That first morning I walked in, the hall was full of paintings. The dining-room was a studio with tins of ripolin, bottles of oil, a scrubbed long table and on the walls many charcoal drawings of bearded heads. I saw real painting, free and authentic, for the first time.[42]

I had, of course, a swag of poems. The ones I first produced had some elements of surrealism and of the romanticism then current in magazines such as *Poetry London*. I also had, but at first was uncertain whether to produce it, a longer poem based on Australian speech-rhythms and with elements which, at quite a long remove, connected with the ballad form: a common idiom of much Australian popular verse. When, finally, I produced it, Nolan, Sunday and John retreated to the kitchen. I gathered later from Joy Hester that an animated conversation took place and Nolan re-appeared in the library, as an ambassador from the kitchen, to talk at length about this particular poem and to suggest it indicated a track I ought to follow.

I make no particular claims for the poem but mention it here as a first-hand instance of the effect of the Heide group on a young artist at a critical stage of development. Such, I imagine, was the experience of many.

Michael Keon and other direct witnesses of that time, including Max Harris, have recorded their experience of the Reeds operating at this intuitive and imaginative level close to the creative act. By some chemistry, some special kind of empathy, they divined what the young artist was struggling to realize. Keon and Harris have both written of the Reeds' effect on the

young Sidney Nolan. They, and perhaps in particular Sunday, participated in a process which crystallized a gift which swung between poetry and an eclectic mix of visual images he made from a wide range of European sources. Nolan, says Keon, 'was at his tide-breasting best at Heide';[43]

> Nolan decidedly was exhilarated, not just by his acceptance at Heide, but about pretty well everything at Heide. Garden, river-side paddocks, Sunday's food, shelves of books, conversation, wine, skylarking, and emotional openness and depth. Exhilarated, happy, absorbed, energized *and* secured. I know, because I was there.[44]

Nolan's experience was to be that of many others: Joy Hester, Mary Boyd, Max Harris, myself. It is all there in our letters to the Reeds.

They offered a rare confirmation to individuals in isolation, not only in the necessary creative isolation, but in a social context where supposedly informed people of taste saw no value in what we were doing. These are the people whose lives Sir Sidney Nolan said recently 'didn't turn out too well' and whose battles, he now thinks, 'were fought for a forlorn cause'.[45]

On the contrary, I and others believe that the Reeds and the artists close to them, by engaging with the emerging art and the dominant social issues of their time with a whole sensibility, created a way of living in Australia which some of us would regard as a vital factor in Australia's coming of age.

It is inevitable that for a time Sunday and John will be identified mainly as people who helped the artists in this exhibition and who preserved and disseminated their work at a time when few others did so.

This required an enormous energy. Their correspondence, which John wrote for both of them, for they were inseparable, is vast and ranges widely from 1930 to 1980 to touch many of the major preoccupations of Australia today. They were among the first to emerge in the long battle for conservation of the environment; they were involved in every major political struggle of this half-century. Their garden is now famous and has a secure place in our garden history. The correspondence reveals an unflagging relationship with many of the most vital people in the arts and in many other areas of our national life.

They could never not answer a letter – or at least not without acute deliberation. They took part in public issues but remained intensely private and took no care at all, it seems to me, about creating a public reputation. They received no honours, they got no official appointments, they were not asked even in the last decade of their lives when a kind of fame overtook them, to judge any major art awards or to give any major public addresses. They were workers and did nothing in an amateur way, rigorous and adult but rarely solemn. They worked on to get the paintings they loved, not only of the generation exhibited here, but of succeeding generations of vastly different painters, exhibited as widely as possible. They took Nolan's first *Kelly* series to Paris and Rome. They negotiated for exhibitions in America, New Zealand and other countries. Long before the days of the Australia Council they did the job it later performed by sending

Sunday, Sweeney and John Reed at Heide, 1950

exhibitions from Melbourne to venues throughout Australia. Joy Hester and Danila Vassilieff both died without one significant work in any public collection. Sunday and John began to seed galleries with gifts. The *Ned Kelly* series was given to the Australian National Gallery. The list of such gifts is a long one. Only in this way could some of the artists they loved get any kind of audience or gain a grudging recognition. Looking back now, with their letters in front of me, I note with some irony that a leading art historian, writing about a posthumous exhibition of part of their collection, complained bitterly that wonderful paintings had been 'hidden away at Heide'.

For a time they will be associated with particular styles associated with Vassilieff, Tucker, Nolan, Boyd, Hester and Perceval. Many

years ago Bryan Robertson expressed a common misunderstanding of the Reeds' taste. He wrote that 'their taste for a certain kind of poetic imagery and their enthusiasm as patrons made an impact in Melbourne which persists to this day not only in its quantity but also in its style – so consistently different to the more abstract nature of the work of painters in Sydney and other cities'.[46] This is not so. From the completely non-objective Atyeo of *Organized Line to Yellow* (*c*.1933) they responded vividly to the best abstract painting all their lives. There is no prevailing dominant style when one considers the whole of the works they brought to Heide, wrote about, exhibited and gave to public collections.

It is hard to see as 'forlorn' lives which engaged with those of so many painters before

51

and long after the period of this exhibition. They went on to create a Museum of Modern Art in Melbourne (1958–65) which gave many of today's most prominent painters their first exhibitions. They built on the Heide property a new house which is regarded as one of Australia's finest examples of modern architecture. It was 'a gallery to be lived in'. Today it and eleven acres of the property is Heide Park and Art Gallery, a public trust operated by the Victorian Government and a major centre for contemporary art and the beginnings of an international sculpture park. When they died they left important works to the National Gallery of Victoria and other institutions and nearly four hundred works to the permanent collection of Heide Park. Most of their estate was also left to Heide Park to form an endowment for the acquisition and development of modern art.

As for the old farmhouse where I now live among the hundreds of shrub roses and the towering eucalyptus, I think they would be pleased that a literary journal is partly edited here, that young poets and painters crash in the front room and think 'all that stuff was ages ago' and that new paintings are still stacked in the hall. The other day a young New Zealander made two sculptures near the 'Doll's House' where Sunday stored Nolan's paintings before sending them all to London. Galvanized iron cows. An indigenous material. They are not in the least sacred cows. John and Sunday would have joined in my laughter and enjoyment. Galvanized irony.

Heide, March 1988

1 John Reed, *Autobiography*; typescript of an autobiography written when Reed was 77. (Reed Papers, La Trobe Library, State Library of Victoria). A chapter was published in *Overland* no. 101, December, 1985, pp.53–60; this quotation p.57.

2 Ern Malley, *The Darkening Ecliptic*, Reed & Harris, Melbourne, 1944, 'Documentary Film', p.24.

3 Margaret S. E. Reed, *Henry Reed; An Eventful Life Devoted to God and Man*, Morgan and Scott, London, 1906, and Sir Hudson Fysh, *Henry Reed; Van Diemen's Land Pioneer*, Cat & Fiddle Press, Hobart, 1973. Fysh was a grandson of Henry Reed.

4 John Reed, *op. cit.*

5 Cynthia Reed, *Daddy Sowed a Wind*, Shakespeare Head, Sydney, 1947. 'Mt Unpleasant' in Cynthia Nolan, *Open Negative*, Macmillan, London, 1967.

6 John Reed, *op. cit.*

7 John Reed, *op. cit.*

8 Goldsworthy Lowes Dickinson quoted in *Essays in Biography* by J. M. Keynes, Macmillan, London, 1933, pp.302–3.

9 Robert Roberts (1901–1947) in a letter to John Reed, Reed Papers.

10 John Reed, *op. cit.*

11 Ern Malley, *op. cit.* 'Petit Testament', pp.43–4.

12 T. S. Eliot, *Criterion*, April, 1933.

13 A. A. Phillips, 'The Cultural Cringe', in *Meanjin*, vol. 9, No. 4, 1950, p.299.

14 A. D. Hope, *Australia* in *The Wandering Islands*, Edwards & Shaw, Sydney, 1955.

15 J. S. Macdonald quoted in Leonard Cox, *The National Gallery of Victoria*, Melbourne, 1970, p.164.

16 John Reed, *op. cit.*

17 Albert Tucker quoted in James Mollison and Nicholas Bonham, *Albert Tucker*, Macmillan, Melbourne, 1982, p.23.

18 *Ibid* pp.23–4.

19 Michael Keon, 'Nolan at Seventy' in *Overland* no. 108, September, 1987, p.16.

20 Joy Hester in a letter to Barrett Reid quoted in 'Joy Hester, Draughstman of Identity', by Barrett Reid, *Art and Australia*, June, 1966, p.53.

21 Albert Tucker quoted in Richard Haese, *op. cit.* p.282.

22 Ern Malley, *op. cit.* 'Baroque Exterior', p.29.

23 John Reed, *op. cit.*

24 Footnote to Editorial in *Angry Penguins*, December, 1944, p.3.

25 Bernard Smith, *Place, Taste and Tradition; A Study of Australian Art since 1788*, Ure Smith, Sydney, 1945, p.268.

26 John Reed, 'Introduction to John Perceval' in *Angry Penguins*, no. 5, September, 1943.

27 Bernard Smith, *op. cit.* pp.218–9.

28 Daniel Thomas discusses the origin and attribution of the much-quoted phrase 'the charm school' in 'Backward Glance at an Avant-Garde', *The Bulletin*, 14 August, 1965.

29 Ern Malley, *op. cit.* 'Young Prince of Tyre', p.37.

30 Richard Haese, *Rebels and Precursors: The Revolutionary Years of Australian Art*, Allen Lane, Melbourne, 1981, p.234.

31 *Angry Penguins*, 1945. Editorial p.2.

32 *Angry Penguins*, 1945. Editorial p.2.

33 Richard Haese, *op. cit.* p.194. Sidney Nolan to Joy Hester.

34 Richard Haese, *op. cit.* Arthur Boyd interview, p.184

35 Ern Malley, *op. cit.* 'Culture as Exhibit', p.33.

36 Ern Malley, *op. cit.* 'Perspective Lovesong', p.30.

37 Ern Malley, *op. cit.* p.5.

38 Alister Kershaw, 'The Denunciad' in *Angry Penguins*, no. 5, September, 1943.

39 Max Harris in his Introduction to *Ern Malley's Poems* (Melbourne, Lansdowne Press, 1961) p.9.

40 Herbert Read, Letter to John Reed in *Angry Penguins*, December, 1944, p.5.

41 Ern Malley, *op. cit.* 'Sweet William' p.19.

42 Barrett Reid, 'Nolan in Queensland: Some Biographical Notes on the 1947–48 Paintings', in *Art in Australia*, vol. 5, no. 2, September, 1967, p.91.

43 Michael Keon, *op. cit.* p.15.

44 Michael Keon, *op. cit.* p.16.

45 Sir Sidney Nolan O.M. in press interviews quoted by Michael Keon *op. cit.*

46 Bryan Robertson, *Whitechapel Exhibition of Australian Painting*, Catalogue Introduction (1961).

Acknowledgements
Especially to Lyn Gemelli of Heide Park and Art Gallery, Melbourne; La Trobe Librarian, Dianne Reilly, and Manuscripts Library, Tony Marshall, State Library of Victoria; Dr. Richard Haese for a decade of conversation and for answering an urgent enquiry. To the late Ern Malley my love and thanks.

Noel Counihan
The New Order
1941
Australian National Gallery, Canberra
No.161

REALIST ART IN WARTIME AUSTRALIA
Bernard Smith

'I am glad to say that I have never considered painting simply as a pleasure-giving art, a distraction; I have wanted, by drawing and by colour since these were my weapons, to penetrate always further forward into the consciousness of the world and of men, so that this understanding may liberate us further each day . . . These years of terrible oppression have proved to me that I should struggle not only for my art but with my whole being.'

Picasso to Pol Gaillard, October 1944, quoted in Roland Penrose, *Picasso* (1958).

Seriously threatened from the north by Japan and with the greater part of its armed forces deployed in the Near East, Australia was extremely fortunate to escape invasion and the destruction of its cities. Although most of them were mobilized either in the armed or civilian forces, Australian artists found ways of continuing their personal work. The traumatic wartime experience produced a new art in Australia of great power and originality that is still little known beyond its shores.

There are parallels with the US but Australia did not become an asylum for modernism. No world-famous expressionists or surrealists, running from Hitler, imported their *angst* to Australia. To a very large extent we were left to cultivate and cope with our own. Whereas the US became the principal theatre of late modernism in its least creative and most doctrinaire phase, Australian artists during the war clung desperately to the humanist components of early modernism and succeeded in developing an art with a public presence; one that did not, however personal its sources, seek to privatize the emotions completely.

Since the publication of Richard Haese's *Rebels and Precursors* (1981) the view has gained ground that the emergence of this new radical wartime art resulted from the triumph of an

open-minded liberalism championed by John Reed and the group of artists associated with the journal *Angry Penguins* over the rigid 'Stalinist' views maintained by the group of social realists centred upon the work and activities of Noel Counihan and Victor O'Connor. In this respect the book has given an air of historical legitimacy to an implicit attitude that has marginalized realist art from the contemporary art market and the curatorial art world since the late 1940s. The book is thus best viewed, despite its documentary value, as a product of aesthetic values generated by the Cold War.[1]

For those who lived through it the wartime art situation was far more complex. During the War realism found favour among a wide range of artists and its influence affected many of the current styles. It was present in the work of artists who professed little or no interest in politics such as William Dobell, Russell Drysdale, and Ivor Hele. Artists were in search of a mode that could relate their personal experience to the wartime situation and many found it in some form of realism, a realism that in the search for personal expression often drew upon expressionism, surrealism, and even constructivism.

Clive Bell had insisted that 'the one good thing a society could do for an artist is to leave him alone. Give him liberty'. Such views rapidly fell out of favour with many young radical artists after the outbreak of war. Mouthing the sacred nature of one's personal right to do one's own thing had not saved a generation of German modernists. What was the role of the artist-citizen in a society engaged in a war universally

considered to be just? That was the over-arching question that at first united and then divided the young radical artists of Melbourne who, led by John Reed, took over the Contemporary Art Society from George Bell, the founder of the Society, and his artist associates within one year of the Society's foundation.

They were all radicals either in their art or their politics, and usually in both. Many, such as Tucker, Harris and Vassilieff, were members of the Australian Communist Party during the early years of the War, and others such as John Reed maintained a friendly fellow-travelling relationship with it by assisting in the Party's election campaigns and in other ways.

The union of avant-garde art and radical politics that developed at this time was expressed in the constitution of the Contemporary Art Society: 'By the expression ''contemporary art'' is meant all contemporary painting, sculpture and other visual art forms which is or are original and creative or which strive to give expression to progressive contemporary thought and life as opposed to work which is reactionary or retrogressive, including work which has no other aim than representation'.

So long as Hitler continued to triumph in Europe and the threat of invasion by Japan remained, the uneasy truce between the apolitical avant-garde and the politically committed artists was sustained. But in 1944 with an Allied victory in sight a prolonged debate, initiated by an exchange between Tucker and Counihan, erupted. The fact that for months this debate was carried on in the *Communist Review*, the CPA's theoretical journal (with Party and non-Party

people including John Reed participating) is itself an indication that the Party had no programmatic cultural programme. It is true that there were intemperate views and dogmatic opinions expressed by individuals on both sides. But it is a falsification of the actual situation to construct it as a contest between liberals and programmatic realists. There is a sense in which, so far as the Australian art world was concerned, Counihan and O'Connor, in seeking an alliance between conservative and progressive artists in the united front against Fascism, were more liberal than the circle associated with *Angry Penguins*.

What has not been sufficiently understood is

Noel Counihan in his studio at East St Kilda, 1947

that the upsurge of wartime realism challenged some of the central assumptions of the modernist aesthetic. The CAS constitution accepted all art except that with no other aim than 'representation'; what the avant-garde of the time did not grasp was that all art is a representation. In practice being modernist in the early 1940s meant gaining your inspiration from child art, primitive art, literature, psychoanalysis or sacred geometry. But those who went *directly* to their own life experience were suspect – that was 'representational' art.

There was nothing at all programmatic about the realism, if that is the word for it, of O'Connor, Bergner and Counihan. What they sought to do, and succeeded brilliantly in doing, was to delve into their own inner feelings and experiences and create works that would stand as a witness to those times, and in so doing share their feelings with others. The fact that such art drew upon many of the traditional skills of the academy and of naturalism meant that it rested uneasily with the de-skilling propensities of modernism. So long as Hitler remained undefeated this odd-man-out modernism was tolerated. But as soon as victory was in sight the tensions engendered erupted in conflict. The realist threat to the modernist aesthetic, however, remained hidden; the debate was conducted at the level of art politics. The realists had committed the unforgivable sin of placing their public responsibility as citizens before their traditional role as artists; had blasphemed the enduring romantic icon, that of the alienated artist creating in isolation and splendour, apart from his own society. Their wartime act was to haunt them for

the rest of their lives. Whenever they held an exhibition during the long years of the Cold War, critics, however laudatory, would feel bound to preface their comments with a caveat recalling that they had once in youth subscribed to the socialist heresy of realism. It served, whatever its intention, as sufficient warning to collectors and curators. The artists experienced difficulty selling their work, it was rarely bought by public galleries, and never included in major exhibitions overseas of Australian art. They were marginalized. Realist art was unspeakable.

Yet a fair-minded assessment will reveal that their wartime work was every bit as personal and passionate, as much involved with the terror and contradictions of those times, as their colleagues who turned for inspiration to French literature, child and primitive art, psychoanalysis, sacred geometry and the archetypes of Jung, and then went on to become the heroes of the post-war Australian art establishment. So that after the passage of forty years one begins to wonder at times, perhaps a little cynically, who then was in it for real and who for their personal advancement?

Consider the case of Victor O'Connor, one of the most sensitive painters of mood and place to emerge during the war years. One of his earliest works, *The Acrobats*, shown in the 1941 CAS exhibition, was singled out by Paul Haefliger, the distinguished art critic of the *Sydney Morning Herald*, as 'one of the most outstanding works in the show'. It shared the Society's prize with Donald Friend. O'Connor was not then and never has been a programmatic realist, and deeply resents being stereotyped as a painter

Vic O'Connor in the 40s

with solely political interests. His paintings arose, in those early traumatic war years, from a deep sense of outrage, of inner spiritual loss, that the civilization of Europe which we had all been taught to admire since childhood seemed on the brink of total destruction:

> Recollections which I was just old enough to have of the hardship and deprivation of the depression years and their injustices began to give me figures and themes to provide some equivalent of the flight and dispossession of the oppressed minorities of Europe and I painted them against the only landscape I knew, the inner city and my view of it.[2]

It was as a result of winning the CAS 1941 prize that O'Connor came into touch with Bergner and Counihan.

Yosl Bergner grew up in Warsaw, a member of a distinguished family of musicians, writers, poets, painters and dancers. His father, the well-known Yiddish poet known as Melech Ravitch, had visited Australia in 1934 in search of a homeland for Jews in the Kimberley district of northern Australia, but the search came to nothing. Yosl arrived in Melbourne at the age of seventeen. He had intended to be a painter from the beginning and had already taken lessons in painting from the artists Altman and Friedman in Warsaw. In Melbourne, though living in conditions of dire poverty, he quickly established relations with the young radical artists of the time, and during the early years of the War, as personal knowledge came through to him of the fall of Warsaw and the destruction of the ghetto, he painted a profoundly moving and powerful series of paintings that for their sustained intensity and melancholy grandeur are without parallel in the art of wartime Australia. Wartime Melbourne, its markets and working people, the urban Aborigines of Fitzroy, were mirrored in his personal experience of loss. To associate such work with the atrocities of Stalin is an obscenity. But it is only during the 1980s that his wartime work has received a measure of rehabilitation in Australia. Fortunately for his development as an artist he left Australia in 1948 to begin a new life in Israel.

It was the intellectual leadership of Noel Counihan that in large measure, though not entirely, held the small Melbourne realist group together, and it is because of his opposition to the views expressed by the ex-Communist painter Albert Tucker that his reputation has had to bear

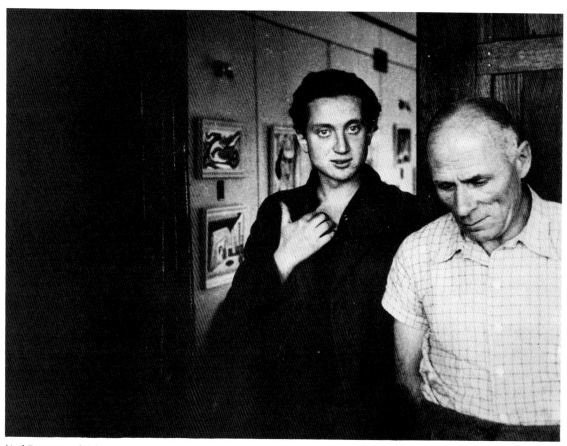

Yosl Bergner and Adrian Lawlor in Lawlor's home at Warrandyte, c. 1941

the guilt-by-association smear of Stalinism. Counihan, a little older than the others, had joined the CPA in 1931; he developed his great natural skills as a draughtsman in graphic art and caricature, and was actively involved in the desperate free speech struggles of the unemployed in Melbourne during the Depression years. On one occasion he locked himself behind the iron bars of a disused elevator hoisted on a truck so that he could address a street meeting for half an hour, before the police succeeded in smashing in the elevator and arresting him.

Counihan turned from graphics to painting, partly inspired by Yosl Bergner while convalescing for a year from tuberculosis in a sanatorium in Victoria. His approach to painting was highly personal, but his socialist beliefs led him to search for a personal art he could readily share with others. He was deeply convinced that art was a sharing of the emotions and distrusted highly individualistic positions. In 1943 when I was writing my first book *Place, Taste and Tradition* (1945), I asked Counihan if he would outline for me the intentions of the realist Melbourne group,

so far as they could be expressed in words. At that time I had not met any of them but had been deeply impressed, in the Sydney exhibitions of the Contemporary Art Society (1941-43), with the passionate intensity and sincerity of their work. He replied, 'Our trend at present is to endeavour to reach the most important, most suggestive social subject matter by digging into the depths of our intimate individual *experience* – that is, the *indirect* approach, to reveal the social relations involved in our most intimate experience'. Their 'realism' required the recollection and invocation of past memories, of former experience, by means of which they constituted their own identities as artists.

John and Sunday Reed bought Noel Counihan's first painting, *The pregnant woman*, painted shortly after coming out of the sanatorium and exhibited in the CAS show of 1941 with a price tag of fifteen guineas. The Reeds offered him ten (or it may have been eight) guineas for it, which he was pleased to accept. But it did not make him over-enthusiastic about the nature of their patronage. Nevertheless it must be said that in the end they put together a most admirable collection. It is now part of the Australian national heritage. Selected young radical artists associated with the CAS in the early 1940s received invitations from time to time from John and Sunday Reed to their house Heide, on the river Yarra on the outskirts of Melbourne, where they maintained a kind of salon, somewhat reminiscent of Lady Ottoline Morrell's at

Garsington, and patronized aspiring young artists of talent. Neither Counihan nor O'Connor ever received an invitation to Heide. Perhaps the Reeds felt, being highly sensitive people, that these two had acquired radical views that might last them a lifetime. Bergner was invited once, but after being accused of stealing he never went again.

Perhaps such small, petty things should not be allowed to disturb the calm waters of today's heritage histories. There were faults of dogmatism on both sides, faults more readily forgiven had the realist artists been given some place in the high art of the 1950s and 1960s. But late modernism developed its own peculiar modes of aesthetic censorship. The realists were marginalized almost to extinction and today only their wartime art is much sought after by collectors and curators. Yet their achievement was formidable. They were the first to depict in Australia's 'high art' the frightful conditions of present day Aboriginal society, and the conditions of working-class life during the great Depression; and they foreshadowed, in paintings of prophetic solemnity, the great horror of the holocaust. Their work deserves to be better known and given a fair go.

1. The book may be compared in this regard with Donald D. Egbert's *Social Radicalism and the Arts* (1970), but Egbert attempts to present a more objective perspective on a world scale.

2. *In.litt.* January 1988.

*Joy Hester and Albert
Tucker in their studio at
Little Collins Street, 1940*

Silence into Image
Women of the 1940s
Janine Burke

It's Thursday afternoon, October 19, 1939. Joy Hester stands in the queue outside the Melbourne Town Hall. She's come to see the *Herald* Exhibition of French and British Contemporary Art. It isn't her first visit. She lives only a few blocks away in Little Collins Street in a loft she shares with Albert Tucker. Today she's come to hear John Reed give a guided tour of the show. Of course, some of the crowd have come only to jeer, to laugh at the daubings of modern art. Joy has a gift for mimicking voices, accents; she'll tell Bert the funniest comments later. She doesn't mind the crowd. Once she's in front of the Picassos, she doesn't notice anyway. Since she left the Gallery School the year before (they gave her a drawing prize but that couldn't hold her. All those interminable casts!) her pen and ink drawings have become looser, the forms more exaggerated and confident. Some of that she owes to Picasso, to the massive forms of his surrealist bathers. The *Herald* show is her first

chance to see the art she admires other than in reproduction. She is nineteen years old.

On her way down Collins Street she had bought *The Argus*. In it is a pictorial supplement titled 'Chaos and Suffering in Poland'. This is what it means, this is what war means. Wounded children, burning homes, people standing in smouldering ruins. She can't close the paper, can't take her eyes off the faces of the children. Europe is a fantastic, far-away place where great art is made and great books written. Now it smokes and smoulders, its people are victims. Yosl Bergner, a former refugee from the Warsaw ghetto, has described in his paintings streets where buildings rise like cavernous crags under whose shadows wander the old, the lonely, the dispossessed. Each morning Yosl arrives at the loft for breakfast. They share a bowl of Weeties and a cup of tea. Yosl is thin, too thin. But she and Bert have so little themselves.

By the time she's inside, it's late and John

Reed has begun his talk. He is a lawyer not an artist but involved both as a member of the Contemporary Art Society Council, like Bert, and as a buyer of paintings, that rare breed. Joy is on the outskirts of the crowd. She hears John say 'The trustees of the National Gallery of Victoria refused to hang these paintings on their walls'. She chuckles, recalling the first Contemporary Art Society exhibition, only four months ago, hung in the National Gallery. It was her first exhibition too: one painting, *Figure*. Then a debate exploded in *The Argus* between conservative artists and the radicals about the worth of the show. John and Bert wrote letters. She did, too. She was part of it.

Since then, there have been discussions about the way the CAS must change. George Bell, its President, is an old fogey and fulminates about ratbag Communists infiltrating the membership. He doesn't approve of Joy and she knows it. Bert told her how Bell took him aside and advised him that Joy wasn't a 'suitable' companion. Bert laughed about it. She laughed, too. To cover up. Why did he say it? Because she peroxides her hair? Because she's run away from home? Maybe it was because she's abandoned her course. It wasn't only the frustration, the tedium. She used to watch Danila Vassilieff, the Russian traveller, set up his easel amongst the street kids of Carlton and polish off a painting. He said an artist didn't need a school. Just life. Right there in front of you.

It is in her, too, that speed, that lightness of touch. It is the way she wants to work, without constraints, without having to mix paints and prime canvases. Looking at the Polish children,

she sees their loss and fear, she sees them becoming, in these moments of change, different people, unknown to themselves. Black and white, darkness and light. She wants to draw, only draw. But drawings are seen as preparations, things waiting to be made into other things. It makes her feel *she* is a thing waiting to be made into another thing. She isn't. She is present. Active. Ready.

She can barely hear John Reed from this distance and decides to wait until he's up to the Picassos. Looking for a seat, she finds herself sitting next to Sunday, John's wife. They've only nodded to one another at CAS meetings. Bert has told her that Sunday has lived overseas, speaks French, has a vast library and a sharp eye for art. How do you talk to a woman like that? Sunday smiles.

Joy says, 'Do you believe in the equality of the classes?'

Sunday considers it for a moment. 'I believe in love', she replies.

It's 1988 as I write this essay. Some of the above is true, some fictional. Joy and Sunday did meet at the exhibition. Sunday recalled their first words to me, forty years later. There was a pictorial supplement in *The Argus* but I don't know whether Joy saw it. Even calling these women by their Christian names implies an intimacy that I am presuming. I'm presuming a discourse between women/artists, between silence and what is spoken, between the presentation of the image and the representation of self, between autonomy and belonging, between the reserves of friendship and the stormier exchange of passion, between trust and

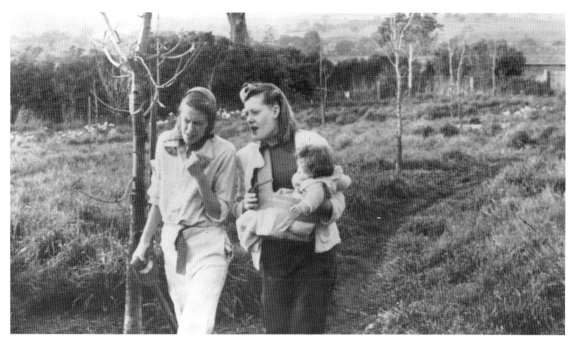

Sunday Reed and Joy Hester with Hester's son Sweeney at Heide, c. 1946

loss. Shortly, another artist will be introduced, Ailsa O'Connor, the only woman member of the social realist group.

They are diverse in terms of class, ambition and 'failure', political belief. They are aliens seeking recognition through art, through one another. All three had 'strong' husbands who stood for combative views about the role and the content of art. These husbands guided them, spoke for them and, in the case of Joy and Ailsa, marginalized them. Sunday, Joy and Ailsa. Three women speaking to each other across forty years of male intervention.

First Ailsa's words:
Many discussions around ideology and theory took place during the war years (usually accompanied by very loud Mozart piano concertos played with hard needles). In the CAS a clear division showed up between those artists grouped around John Reed and ourselves. The other group were Tucker, Nolan, Boyd, Perceval. Joy Hester and Yvonne Lennie were their slightly invisible members (as I was within the left group).[1]

Ailsa has come down from the country, 'avid for art'.[2] At sixteen, she attends art classes and manages to cram in a teacher-training course. At nineteen, she is standing in front of a class of boys in a working-class Melbourne suburb. It is 1940. There are two wars going on. One is the real War, the other concerns art. The Angry Penguins against the social realists. Ailsa has sold her school uniform and books to pay for classes at George Bell's where she meets Vic O'Connor, her future husband.

Because of the lines drawn between the two groups, Ailsa and Joy will never become friends.

What unites them during the war years is their choice of subject. They both paint women. Ailsa paints the women workers she gets to know as a Communist Party cadre. They walk together in the streets, seeking comfort and solidarity from the warmth of physical contact. Ailsa's women inhabit a known and ordinary world, a world that is to be transformed through the programme of socialism, a world in the process of becoming. Ailsa's women are bonded through female strength. Within the Communist Party, Ailsa knows many women, active, articulate, committed, on whom to base such positive images. She is, however, alone as a woman artist and her involvement with the greater cause of socialism excludes her artistic practice, just as she is excluded from taking real power in the social realist debates. All her paintings from this period are lost.

Joy distrusts theory, theoretical explanations. Like many artists and intellectuals of the war years she is a Communist Party fellow-traveller. In 1942 she lives in a state of fear. She transfers this to her drawings: she places her women like *The Mad Girl* in a site of psychological unease. In 1940-41 she too, like Ailsa, draws women in the street but while the bodies of Ailsa's women are solid and realistically rendered, the bodies Joy draws are airy, elongated, weightless. The line that will become characteristic of her is rhythmic and vibrant, restless, broken, fine. Form is compressed and emphasis rests with an eye, a hand. Backgrounds are slight and casual: it is the relationship between the women that is important.

In 1945, sitting in a Melbourne cinema with her young son Sweeney, Joy will see the first footage of the Bergen-Belsen concentration camps. Horror resounds in her drawings like a wail of pain. She draws emaciated bodies lying abandoned near fences or swinging from gallows. But it is in the faces that the knowledge of violence is fully realized. From expressions of anguish, from wild staring eyes, from mouths and jaws and foreheads distorted by grief comes the message that consciousness, even humour, can be sustained under such burdens and that individuals can survive to come back as witnesses though, inevitably, as altered beings.

Outside the Communist Party, within the Angry Penguins group where Joy is the only woman member to come through the war years as an *artist*, and as a member of the CAS depleted of its women members since most left with George Bell in 1940, Joy is alone – except for Sunday.

The older woman and the young artist become best friends. When Bert goes into the army in 1942, Sunday invites Joy to live at Heide. Sunday is at the centre of an intellectual group and a domestic life. Her work is her garden, her home, friendship, the art of her time. She is 'behind' *Angry Penguins* as Ailsa is 'behind' the social realists: supporting, understanding, organizing. Sunday is there as Nolan paints, there as Joy sits drawing near the fire, there as arguments rise, there when money is needed. Sunday's 'visible' contribution to the *Angry Penguins* journal? The translation of three poems by Rimbaud.

But in the rich and marvellous intimacy Sunday weaves, there can also be disharmony.

Her home, into which so many are welcomed, can be a place of tension, the site of another kind of power, for Sunday is a mistress of atmosphere. She has a deep sadness to do with a child she cannot have. She has times of depression and weeping, of feeling purposeless. Because she invests so much in friendship, she is devastated if it fails. Outside her marriage, she has affairs. So does Joy. Joy keeps her 'other life' a secret until it can no longer be kept secret; until in 1947, she leaves Bert for Gray Smith. For Sunday, other loves are managed, skilfully woven into an emotional economy both supple and fragile.

Sunday and Joy strive to understand one another across age and class, across difficulties to do with possession and freedom. They finally succeed. Joy writes her last letter to Sunday, in hospital, dying from leukaemia.

> The days come and go and I think of you . . . your flowing thoughts to me over the years and so much lately make myself shake with my own inadequacy, the spear of your warmth and guidance reaches perpetually to my heart. I rejoice, am happy, but how can I do this for you? . . . You have always given me so much pleasure because you bothered to follow what my silly dreams were.[3]

In 1947, when she finds she has Hodgkin's disease, Joy leaves Sweeney, now two, with Sunday and begins a new life, first in Sydney, then in the countryside near Melbourne. John and Sunday will adopt Sweeney. Joy will have two more children, Peregrine, a son, and Fern, a daughter, by Gray Smith. Ailsa will have Megan and Sean. Joy will die a young artist, only forty, and will leave behind several hundred drawings,

half a dozen paintings, many poems. Ailsa will return to art school in her forties and will produce sensuous and beautiful sculptures of women. She will become a member of the women's Art Forum where her wisdom and gentleness influence many younger women. Posthumously, her writings on art are published. Joy Hester will be the subject of several exhibitions, a major retrospective, a monograph. All three are 'represented' in this *Angry Penguins* exhibition.

Of the three women, Joy Hester made the clearest decisions about her creativity, alarming and disruptive choices that changed the pattern of her life and the lives close to hers. Ailsa, after many years of work for the Communist Party, the peace movement and the women's movement, was able to find her way back to art school, to her destiny as an artist. She died in 1980, Sunday in 1981, some few weeks after John, at Heide. There are two Heides now: the newer one is a museum of Sunday and John's collection. But Sunday's garden is there. So, too, is her spirit. Ailsa's home also has a special function, as a place where young women sculptors can live and work in the comfortable studio Ailsa built in her garden.

1. Ailsa O'Connor, *Unfinished Work, Articles and Notes on Women and the Politics of Art*, Greenhouse, Melbourne, 1982, p.35.

2. *Ibid*. p.25.

3. Janine Burke, *Joy Hester*, Greenhouse, Melbourne, 1983, p.173.

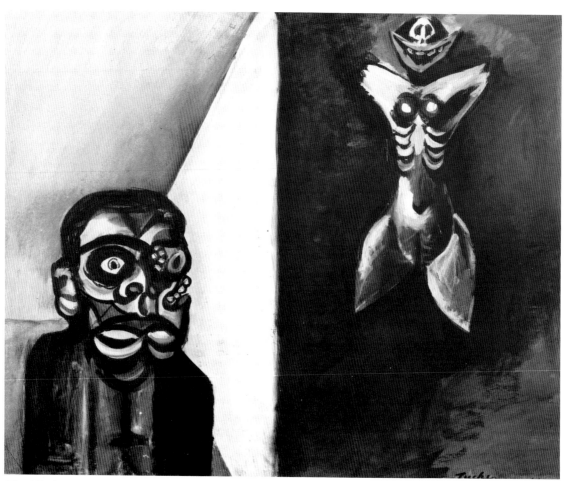

Albert Tucker
Image of Modern Evil: demon dreamer
1943
Australian National Gallery, Canberra
No.67

MODERNISM FROM THE LOWER DEPTHS
Charles Merewether

'Both are torn halves of an integral freedom, to which, however, they do not add up.'
Adorno

A peripheral body

The work of the artists in this exhibition appeared in the midst of a culture that was confronted in different ways by the limits and truth of human experience. This experience was more than anything else the effect of having been born in the aftermath of the Great War, raised during the Depression and the rise of Fascism, and having come to maturity with the outbreak of the Second World War. The violent rupture and break that occurred at both an individual and social level forced to the surface the once-secure belief in the notion of identity. For these artists, as for many of their generation, the fundamental question was one of belief, a belief in the possibility or the impossibility of recovery, of renewal and liberation from what appeared to be an entry into an epoch of darkness.

These images reflect the way a small group of artists constructed a vision of their times, of the relation between history and the imagination, of the social and the unconscious. The radicalness and commitment to both individual and social experience became the subject of an extraordinary struggle between different groups of artists, writers and intellectuals and their art. In this context there were two key aesthetic practices, one based in modernism and the other in social realism. Yet even these terms are insufficient, for in many respects their work not only overlapped, at times confounding any clear sense of these movements; it was also ultimately propelled by the force of each other's presence. They represent a generation of voices of protest, despair and resistance. What is so significant about the appearance of this work is not simply its violence, its eloquent demand or its sudden emergence, but its figuration of a profound historical change.

The art of Counihan, Bergner or O'Connor adheres to the principle of realism. There is a belief that art can bear witness to experience, that is, re-present 'reality' and therefore show the truth. The work seeks to express and provide a social knowledge, a truth to which one can appeal. It is shaped by a belief in a residual moral and ethical order of humanity. Counihan's *In the waiting room* (1943) actively participates in the constitution of such a belief. Art could become central to the recovery of a community; artists would become storytellers, the voice of the people, constructing a narrative of truth. This is most evident in the structure of paintings by Counihan and O'Connor, and especially in Bergner's series of paintings based on memories and stories of the plight of the Jewish people under Fascism. The human body's condition is constituted primarily at the level of the social. Through this identification, which their art should seek to re-narrativize, the individual could regain identity and rediscover himself within a social order and community. For Counihan and O'Connor this meant an identification based on class; for Bergner it was a question of race. In this respect Bergner's contribution to Australian art remains unique. Unlike his contemporaries, his commitment to the issue of race oppression led him to paint scenes representing brutality against Aboriginal people.

There is, however, a quite different kind of image present in the work of the Angry Penguins artists. Equally preoccupied by the image of the human body, their encounter is with a figure whose very livelihood is founded in a condition of loss rather than in an investment in the social body or recovery of a future order. The power of this art does not lie in its ability to act in the name of faith, rather it bears witness to the contaminations and the horror of the social body as a place of denial and destruction, of its own wasting and impotence, such as Tucker's *Spring in Fitzroy* (1941) or Boyd's *Progression* (1941). In the art of the Angry Penguins the notion of a consensual identity serves only to marginalize, exclude or repress difference; this is the reason for the violence of the work. It is difficult to pin down or characterize the way the body is imaged in this work. However, it remains in all its guises, influences and phases, profoundly modernist. Overwhelmingly the motif of the body constitutes a being associated with vital *élan*, an expressive force, an unstable figure.

As a bearer of signs and an agent of structures of everyday experience, the body constitutes a site that inscribes at once a relation and a difference between the social and the individual unconscious, between history and subjectivity, between the real and the imaginary. In this sense the figuration of the body in this epoch of Australian art marked not only a significant shift in Australian painting, but made possible the reintroduction of the question of subjectivity and identity in terms of the social.

The course taken by the Angry Penguins and the social realists becomes a mutually dependent but impossible dialogue of differences. Both incessantly return to this vision of the individual body bearing the marks of violence and denial. In uncovering or recognizing the frailty of identity, the image of the body becomes a central and

recurring motif for their critique and vision of the human condition and social domain.

The margins of modernism

Edward Said, in his book *Orientalism*[1], has spoken of the way the West constructed the Orient as a fictive but ideologically measured space. This was achieved through an appropriation and naturalization of its subject, as well as the constitution and maintenance of difference. Modernist culture could likewise be seen in such terms, continuously constructing and reconstructing itself in peripheral or colonial cultures, and therefore at once universalizing the subject, but erasing cultural difference. This itself becomes a part of the very process of colonization, a play of projections, doublings, rejections and idealizations.

In general, evaluations of 'histories' of peripheral cultures, including Australia's, are written from within a model of dependency; questions of the 'development', 'emergence', 'value' and 'distinction' of Australian art are written in terms of a gradual break away from dependency. These are histories of influence, where an imported style or model is copied, assimilated or modified. For such authors the art is ultimately derivative and therefore exists at a second degree level. The concept of cultural value is deferred as originating elsewhere.

The opposite to this model of dependency simply posits the concept of a culture constituted and developed independently of any other extra-national influences, diminishing notions of cultural difference and generalizing concepts of identity. An inversion effect is produced so that

the question of identity is magnified. Identity can only be achieved through assimilation of 'foreign' and local differences under the aegis of a national ideology which, in turn, is sustained precisely through its relation to the metropolitan centre. These ways of approaching the question of peripheral cultures do nothing but confirm the strategies of colonialism and neo-colonialism.

The significance of the European avant-garde was their engagement with and critique of modernism. They sought to locate the disturbances covered by an appeal to an identity based on a notion of a social order.

One of the fascinations in the work of the Melbourne-based Australian artists of the 40s, especially that of the Angry Penguins, is the sense of estrangement that dominates it. It is as if they drew upon the whole body of European modernism, in such a manner as to critically distance their relation to the social context in which they found themselves. What they distilled and mobilized most especially were ideas and techniques of the avant-garde (notably Expressionism and Surrealism), used as ways of disrupting the subject, and making strange the familiar everyday.

Rather than seeking to participate in some universal or trans-modernist culture, they were concerned to mobilize techniques by which to disrupt the local. This opportunity was all the more possible because, as a peripheral society, their appreciation or knowledge of European culture was at best fragmentary, discontinuous, uneven, dispersed and delayed. In these terms there exists a very real possibility of producing art which is out of step, criss-crossing and

hybridizing modernist paradigms and movements emanating from the centre.

It is also, perhaps, no coincidence that the emergence of a critical modernism in Australia coincided with the development of a commodity-based and urban-based manufacturing economy, and a mass-media industry. Such factors offer the means of rethinking the powerful influence of newspapers, magazines, pulp novels and the cinema and the fragmentary, hallucinatory quality of much of their image-making. For instance, Tucker's *Images of Modern Evil* are characterized by an extraordinary breakdown of the body into parts, by their dislocation as objects, and by the constant uncertainty or shifting ambiguity between animate and inanimate forms.

The work of these artists constitutes the first real appearance of a local avant-garde critically engaged in the question of the constitution of the individual subject and the forces of repression, aggressiveness and destruction which, they believed, lay at the heart of modern society, and of which Fascism and war were symptoms. At the same time this made possible a recognition, through their use of modernism, of the condition of marginality at the heart of Australia's obsessive quest for identity. The social order conspires through laws, prohibitions and regulating institutions to erase difference and construct a harmonious social body of consent. The subject of their art is about the effective power of this social order, as a force of repression and violence.

Creativity and modern life

As with European critical modernism (in particular Surrealism), and in keeping with modern theories of education and the arts (such as those of Herbert Read) the Angry Penguins believed that creativity flourished at the margins of society. The figure of the 'primitive', alongside that of the insane and the child, represented models of creativity, who were in touch with themselves at the level of the unconscious, the hidden source of inspiration.

In this context the arrival in the later 30s of Danila Vassilieff and Yosl Bergner was tremendously important to this generation of Melbourne artists. Both Vassilieff and Bergner appeared at a crucial moment. The Contemporary Art Society was formed in 1938 to promote and defend modern art and fight against the conservative and reactionary politics of the Australian Academy;[2] and in 1939, the first major exhibition of European modern art was opened in Melbourne.

Only twenty when he arrived, Bergner had a complete commitment to painting as an immediate and direct form of expression, and it was this commitment, as much as the raw vitality of the work itself, that captured the attention of his fellow artists. Vassilieff's idea of a spontaneous, untutored art as the most authentic form of artistic expression also exerted a powerful influence on his younger contemporaries. Each of them came under Vassilieff's influence insofar as his method and outlook challenged the studied academicism of the art schools and studios. It made of painting a medium which could be approached more spontaneously and directly, and as a form not only of creative expression, but more direct response to the world about them. Nolan, in particular, seems to have been inspired

by Vassilieff, as by his own artistic models (Henri Rousseau, Matisse and the Symbolists). Like his St. Kilda beach and Luna Park paintings, the *Ned Kelly* series creates a new poetic vision of Australia; that is a kind of fabulous illustrated children's book of history.[3]

Vassilieff also believed in an equation between modern art and liberation. Art was directly related to an individual's experience of life; potentially anyone could become an artist. The importance of unfettered creativity, of spontaneous expression, can be seen not only in his approach to painting, but in his choice of subject matter, such as *Street scene with graffiti* (1938). His early Melbourne work shows images of movement, graffiti on the wall, children playing in the streets and portraits of women. In his constant return to these subjects we see a typically modernist belief in sensual life-being of which art was both an expression and an extension.

Vassilieff's later work of the 1940s and of the post-war period showed marked changes, as well as continuities. The space of creative, sensual life, the animation of nature, gave way to a far more introspective, subjective world of human relations. As with his modernist contemporaries, anxiety dominates his work. In, for instance, *Poverty and prostitution* (*c.*1943) the figures are drawn with distorted features, the subject pushed up against the picture plane; there is little depth of field, creating a claustrophobic space or an uncertain interior world in which figures and faces emerge only to disappear again amid dark pools of paint and mere surface. This work is in this respect close to the mood and character of

Perceval's paintings, a world of fantasy and projection.

The criminal, the insane

Fundamental to the work of these artists is their fascination with the psychological dimension of modern life. This fascination, profoundly modernist in character, opens up the domain of individual consciousness and subjectivity, and the imaginative space of war as experienced at a distance.

Foucault has suggested that there was an obligation on authors to ferret out and reveal their innermost secrets as well as a preoccupation with the ugly little details of everyday life. Modernism in Australia was to bring into discourse this 'psychological' dimension of everyday life. Foucault goes on to point to the importance ascribed to familial relations and their disturbances, and to an obsession with crime and deviance that may lurk within us – subjects which needed exposing, uncovering. The interest in the insane, the ill or criminal and deviant were all used as metaphors of disclosure of a human condition. The figuring of the eye, so prominent in the work of Tucker and Hester, and to a lesser extent Boyd and Perceval, might not only have sexual connotations (following Freud and the Surrealists), but suggest a kind of paranoiac eye of fear, guilt and uncertainty: the eye of surveillance or surveyed as if the very surface of form could reveal an inner truth of the unconscious.

The insane, criminal and ill represent forces which have broken with the discourse of social truth and the regime of social order and

accountability. The patient becomes the model of creativity for the artist. These figures are animated by a vital excessive force, surfacing as unintelligible behaviour, only to be medicalized and identified by the social institutions of the State. They become the subjects of disorder: hysteria, disease, perversion, schizophrenia. They also represent the modern condition of social estrangement and alienation; above all else, they symbolize the uncertainty and instability of belonging to an increasingly dispossessed middle class, profoundly affected by the advent of the Depression and the war years.

The Surrealists, especially André Breton, were influential in the development of these ideas; so also were the writings of medical psychiatry and psychoanalysis, especially Viktor Löwenfeld's book *The Nature of Creative Activity* (1936, translated 1939) based on the author's research into the visually handicapped and the blind, and the work of the Melbourne psychiatrist and psychoanalyst, Reginald Spencer Ellery. Both inspired and endorsed the attitudes of artists and writers such as Max Harris, editor of the *Angry Penguins* magazine. Löwenfeld made a key distinction between the 'haptic' and the 'visual' artist. The 'visual' artist wanted to bring the world closer to himself; the 'haptic' artist was concerned with 'projecting' his inner world into the picture. 'Haptic' art is the manifest form of bodily experience where:

> The importance of the environment
> diminishes and experience is more and more
> confined to the processes that go in the body
> as a whole, bodily sensations, muscular
> innervations, deep sensibilities, and their

various emotional effects.

For these artists this was the essence of the rupture between the self and the social: the disunity of experience and the relation between themselves as artists and their art. It became, for instance, central to Tucker's way of thinking about pictorial construction, particularly his series based on his experiences of the Heidelberg Repatriation Hospital, a hospital filled with prisoners and victims of the War, shell-shocked, injured and in states of psychosis. The paintings, such as *Possessed* (1942), with the space compressed down and around the figure, and the colour raw and intense, suggest at once a very real emotional condition and derangement of the senses.

The association of madness and violence with the War is present throughout the work of Boyd, Hester and Perceval in distinct ways. In a manner not dissimilar to Tucker's, Hester's paintings such as *Harry* (1942), or even *Portrait of Michael Keon* (1942) are suggestive, in their construction, of a madness entering into the world of everyday life, particularly the world of women.

Hester's isolated figures, in conditions of confinement or exclusion, delineated with a line that marks out a form rough and uncertain in its boundaries, suggest a level of vulnerability and anxiety as much as a state of fantasy or unreality bordering on madness. More than any of her contemporaries Hester produces a powerful image of individual identity under threat. Her later output, such as the series *Incredible Night Dream* (1946–47) or *Face* (1947–48), extends and elaborates this earlier theme of identity's fragility

or imminent loss; but with an even greater emphasis on the figure of woman and a modernist impulse towards an autobiographical discourse. The great majority of drawings and gouaches show a severe reduction of the figure, a dramatic foreshortening and flattening out to a point where distortion suggests a condition of misrecognition. For instance time and again the eyes are virtually separated from the body and the face rendered mask-like to dramatize a sense of the self as a socially constructed subject breaking down.

Both Boyd and Perceval paint images where the effects of war begin to spill over into the street. Again, as with Tucker, Perceval dramatizes this experience of uncertainty, ambiguity and yet fascination and fear in the visible world. In *Floating mask no.1* (1943) he utilizes the mask to confound positions of innocence and experience or good and evil. With both artists the city by night becomes the 'scene' of this decline into a condition of uncertainty. In Perceval's *Soldiers at Luna Park* (1943) two soldiers and a woman between them gaze onto Luna Park's dazzling lights and movement, which beckon entry into a larger-than-life horror-show of amusement. As in Nolan's earlier paintings and in a later work by Hester (*Fun fair, c.*1946), the image of Luna Park becomes a metaphor for the vicissitudes and uncertainties of contemporary life, see-sawing back and forth between utopian innocence and modern experience, seduction and horror. In Perceval's *Negroes at night* (1944), with its heavily layered paint, an urgency of form erupts like some fantastic vision over the city skyline. Black musicians, figures dancing wildly or hovering

together, transform the city of Melbourne into a scene of excess and mayhem. At their best Perceval's paintings, with their pulsating colours and forms merging, breaking up and dissolving, release an extraordinary energy of the imaginative force of fantasy, breaking up the rational ordering of the senses and the material forms of the visible world. All becomes animated, manic in its excess and expenditure.

With each of these artists, we find what is paradigmatic to critical modernism and to the avant-garde: a constant movement between an expression of the unconscious and a reflection of the social, the two colliding and collapsing into the constitution of individual identity and subjectivity.

Obscure origins

Boyd's extraordinary drawings and paintings of the war years reflect a distinctly individual image of contemporary life and a very real sense and experience of illness, which then find a literary equivalent providing the basis for some extraordinary work. For instance Boyd has referred to his father's epilepsy and his discovery of Dostoyevsky's *The Idiot*:

> Then a yawning chasm seemed suddenly to engulf him. An extraordinary inner light illumined his soul . . . Then came an instant loss of consciousness, an intense darkness blotting out everything . . . At such moments the face, and especially the eyes, become suddenly and dreadfully convulsed . . . the sight of a person in a fit of falling fitness evokes in many people a feeling of intense and unbearable horror that borders on the mystical.[4]

Boyd evokes images of arbitrary and incidental violence, an obsessive, cloying narcissism of love and desire, and a mock celebration of life and death. The drawings have a powerful immediacy with their swiftly drawn line repeated over and over as if almost to erase and scar the original form. The paintings, such as *The gargoyles* (1944) or *Kite fliers* (1943), are overloaded with paint to a point at which figures and scenes merge into lines and forms that dissolve into a swirling frenzy of disembodied gestures. In these paintings, with their depiction of Victorian-style terraces in the beach-side suburb of South Melbourne, the rooftop gargoyles take on an animated life, leaping out to threaten the figures below them in the street. As in the work of the other Angry Penguins artists, inanimate forms suddenly transform into threatening figures. Paintings such as *The beach* (1944), *The hammock* (1944), *The orchard* (1943) and *The cemetery 1* (1944) shift from suburbia to wilderness, between real and imaginary spaces, a breeding-ground of bodies metamorphosing, half-human, half-beast, mingling in the half-light. The images are filled with an erotic doom where a community of figures act out desperate gestures of ecstasy and lament. This is a world where man, animal, child and woman return to their origin, to the primary moments of life, narcissism and desire, birth, copulation and death.

Boyd's work of the mid-40s takes on a more mythic dimension, still addressing this theme, re-utilizing the Old Testament, but now located in the Australian wilderness. Boyd offers implicitly a critique of a conservative and idealistic construction of the land, to reinvoke the question of the origins of Australia and of mankind, as for example in the painting *The mockers* (1945).

In *Melbourne burning* (1946-47) the city is shown as overcome by fire and deluge; citizens flee the conflagration of destruction. A vision reminiscent of Breughel or Bosch, the burning of the city is the end of civilization. At its centre stands a figure of death, triumphantly gesturing amid the blaze. Animals and humans flee, the ground is littered with bodies; others still alive retreat into the dark recesses of the bushland beyond the city. Boyd returns us to the place of origin, to the obscure foundation of western civilization which Australia is doomed to repeat.

As Bernard Smith has suggested, three distinct interests continue to stimulate the Angry Penguins group of painters; firstly the fascination with the portrayal of criminals and psychotic types; secondly, the interest in myth; and thirdly, a desire for some kind of national identification.[5] The significance of these three themes lies precisely in their overlapping so that the question of identity, on the one hand, is underscored by its mythic and socially constructed character, and on the other hand, is found always at the margins of Australian society. The history of white Australia is founded in outlawry, following its convict origins. The figure of Kelly in Nolan's paintings is constructed through the superimposition of two distinct styles of painting, conveying a sense of displacement, of alienation from place or from the land. Unlike Boyd's work, the landscape has a lyrical beauty to it, a quality then pushed back by the harshness of this chapter in Australia's social history. The black helmet of Kelly is like a black

scar on the face of the country.

In these same years Tucker begins his equally massive series of paintings about the modern city, *Images of Modern Evil*. As in his earlier work, he creates a fearful vision of an estranged world. Woman as subject is erased, and the body fetishized into a sexual object. Here modernist subjectivity reaches its limit, a border where, grounded in a politics of marginality and anxiety, perception so fetishized social relations that all sense of identity is turned into a paranoid and uncanny nightmare.

The period of the 30s and the War years saw for the first time a radical artistic practice in Australia, one that addressed the construction of the modern subject. Throughout the work of these artists modernism is used to violently uncover the myth of a social and national identity, and the peripheral condition of Australia. Their art opens up across the spectre of horror and death, the perversion of desire, of repression and madness, the civilized lie and the impossibility of a moral and ethical order or passage of recovery and redemption. This critique was constructed against that of the social realists and the Communist movement, in which 'the health of the body' is constituted through the primacy of the collective identity of the community, and an aspiration toward a harmonious, moral consciousness of life. Difference is seen as an individual disorder. For the Angry Penguins artists, the body is made an inauthentic subject, a figure of taboo and exclusion, the individual without qualities, and an object of fetishism. Unable to identify with the proletariat at an organized level (as did the social realists) and fearful of the prospect of a mass culture, the Angry Penguins increasingly found themselves isolated as dissidents of their own class, but with nowhere to go. Stripped of any transcendent ethical purpose, the critical impulse of this art is to point to itself. This is the force of its vision, an art illuminated only by the darkness of the night.

Spain, February 1988

1. Edward Said, *Orientalism*, Random House, New York, 1979.

2. This Academy was instigated by the Attorney-General, Robert Menzies, who fostered a policy of appeasement towards Fascism and banned anti-Fascist activities.

3. The *Angry Penguins* magazine went on to discover various primitive or *naif* artists and in this context the appearance and their celebration of the poems of Ern Malley is indicative of this attitude towards creative expression. The fact that subsequently Ern Malley was discovered to be a hoax, an elaborate fiction of the two Sydney writers Harold Stewart and James McAuley, did little to alter their opinion of the poems. Sidney Nolan especially endorsed the work.

4. Quoted in Grazia Gunn, *Arthur Boyd: Seven Persistent Images*, Australian National Gallery, Canberra, 1985.

5. See Bernard Smith, *Australian Painting 1788–1970*, Oxford University Press, Oxford, 1971.

Danila Vassilieff working on his home, Stonygrad, at Warrandyte in the early 1940s

CHRONOLOGY
Christopher Heathcote

1937

Joy Hester (1920–60) enrols as a 'Junior Antique Student' at the National Gallery School in Swanston Street, her instruction mainly consisting of scrupulously copying plaster casts. She starts a collection of artworks reproduced on postcards which her mother later finds and burns.

Arthur Boyd (b.1920) exhibits landscape paintings at Seddon Gallery, Elizabeth Street.

Yosl Bergner (b.1920), a refugee from Warsaw, arrives in Melbourne, and after paying a £1000 Jewish landing fee (£200 for other races), is allowed to settle in the severely depressed inner city suburb of Carlton. Australian suburbia is, according to the aging painter Norman Lindsay, a 'Kingdom of Nothingness . . . a cloud of midges in a frenzied love dance above a manure heap'.

June With a policy enshrining the heroic pastoral values of Australian art from the 1890s, an Academy of Australian Art is officially launched by the Federal Government 'to set standards of excellence and taste'. Although there is no organized resistance artists see its role as stifling the development of experimental art forms under what one writer calls 'the dead hand of the past'.

July Russian artist Danila Vassilieff (1897–1958) and his *de facto* wife Helen MacDonald move to the Melbourne inner-suburbs from Sydney, Vassilieff's paintings taking the poverty of immediate surroundings as their subject. Quickly becoming the toast of avant-garde circles his first local exhibition opens at Riddell's Galleries, Little Collins Street, in September; Hester meets Vassilieff.

Modernist artist and *Sun* art critic Adrian Lawlor (1889–1969) publishes *Arquebus* – a satirical *exposé* of the workings of Australia's art establishment which carefully dismisses the Academy as a reactionary body.

1938

February
Vassilieff exhibition, Riddell's Galleries.

Searching for a patron, a cocksure young art student, Sidney Nolan (b.1917), presents himself at the office of John Reed (1901–81), a solicitor interested in modern art. Reed invites Nolan to his home, Heide, a farm on the Yarra river at Heidelberg, seven miles east of the city. A firm friendship will evolve, Reed and his wife Sunday supporting Nolan intermittently for the next eight years.

Hester leaves home to live with Albert Tucker (b.1914), a painter friendly with Lawlor and the Reeds. Unhappy with the teaching, Hester discontinues her studies at the National Gallery School.

Following complaints from the German Embassy a locally-produced anti-Nazi play *'Til the Day I Die* is banned, joining a list of over five thousand illegal literary and theatrical works including texts by Defoe, Joyce, Lawrence, Hemingway and Orwell.

Russell Street, Melbourne, in the early 1930s

June
George Bell (1878–1966), forward-thinking proprietor of an independent Melbourne art school, savagely attacks the backward-looking Australian Academy in the *Australian Quarterly*.

July
After months of discussion on the Academy issue, Lawlor, Reed, Bell and others with modernist leanings call a Melbourne meeting of 'all artists'. Nearly two hundred artists attend and a Contemporary Art Society is formed, membership being unrestricted. Hester, Nolan, Tucker and Vassilieff are among its first members.

Sidney Nolan marries Elizabeth Paterson, a fellow student from the Gallery School. The couple move to the coast for twelve months; Vassilieff works privately in Bell's school.

The wheat crop in Victoria fails.

October
Vassilieff exhibition, Riddell's Galleries.

1939

January *'Black Friday', the 13th, named after extensive bush-fires join to encircle Melbourne, destroying surrounding townships and blanketing the city with a thick pall of smoke.*

Lawlor loses his home and collection of over two hundred paintings at Warrandyte, a small town located in thick bushland twenty miles east of the city.

Tucker discovers reproductions of early *Blaue Reiter* German Expressionist works in the State Library. Together with the Leonardo Bookshop and the mock-bohemian Café Petrushka (both in Little Collins Street), the Library becomes a window open to the modernist world for Hester, Tucker, Nolan, and the art student milieu.

After several years painting in England, ex-Bell student Russell Drysdale (1912–81) and his wife Elizabeth arrive in Melbourne. Drysdale takes private studio space in the Bell school (corner of Bourke and Queen Streets), meeting Vic O'Connor (b.1918), a law student attending after-hours art classes.

Vassilieff moves to Warrandyte and commences teaching art at a local independent school.

Tensions arise in the Contemporary Art Society as membership polarizes into two factions: the radical modernists led by Reed and Tucker, and the moderate post-

impressionists organized by Bell and Lawlor.

Bergner rents a loft above a garage as his first makeshift studio. In addition to establishing contacts with Jewish Communist groups, he meets Arthur Boyd and Noel Counihan (1913–86), the three holding a group exhibition at the Rowden White Library, Melbourne University Student Union.

June *Inaugural Exhibition of the Contemporary Art Society*, National Gallery of Victoria. Predominantly a regional post-impressionist exhibition, different directions are announced by experimental modernists including Hester, Counihan, Drysdale, O'Connor and Peter Purves-Smith (1912–49). Already Albert Tucker and James Gleeson (b. 1915) are flirting with surrealism, while Nolan puzzles viewers with a single Klee-like abstraction.

Joy Hester meets the Reeds, visiting Heide. Sidney and Elizabeth Nolan open a pie shop in Lonsdale Street.

September *Britain declares war on Germany. Prime Minister Menzies announces that it is his 'melancholy duty' to confirm that 'Australia is also at war'. All German-born residents are rounded up and interned.*

October *The Herald Exhibition of French and British Contemporary Art*, Melbourne Town Hall. Assembled by *Herald* art critic Basil Burdett, the exhibition includes seven

paintings by Cézanne, nine by Picasso, eight by Matisse, six by Bonnard, and a selection of works from the Surrealists and School of Paris. Scorned by staff from the National Gallery of Victoria as 'the product of degenerates and perverts', the exhibition is Australia's first and most notorious encounter with 'Modern Art'.

1940

January	*First Australian troops are dispatched to fight in North Africa.*
	Vassilieff and Helen MacDonald start building a home at rural Warrandyte. Nicknamed 'Stonygrad' (literally 'stony place'), the dwelling is assembled from a crazy mixture of rocks and urban debris, with help from Hester and Tucker at weekends.
February	On their third Australian tour de Basil's *Ballets Russes* give the première of *Icare* by Serge Lifar at the Theatre Royal, Sydney, with sets and costumes designed by Sidney Nolan.
March	Vassilieff exhibition, Riddell's Galleries.
April	Lawlor retrospective exhibition, Athenaeum Gallery, Collins Street.
	Counihan leaves Melbourne to travel through New Zealand for several months. He contracts tuberculosis while away.
	Rejected for military service, Drysdale moves to Albury on the Victoria–New

South Wales border in order to explore the theme of rural poverty and struggle. After several months he settles permanently in Sydney.

May	The Government decides that in spite of the War suburban competitive sports should continue as a public 'morale builder'. A percentage of ticket sales are to go to War charities, and football players fees are to be reduced from £3 to 30 shillings per match.
June	Nolan holds an exhibition in his Russell Street studio behind the National Gallery of Victoria. *Herald* critic Burdett frowns on the work as 'too esoteric'. Arthur Boyd wanders in and introduces himself one afternoon.
	Unable to reconcile themselves with the aggressive cultural politics of the radical modernists, George Bell and the post-impressionist bloc secede from the Contemporary Art Society.
August	*Angry Penguins 1*, an experimental literary magazine edited by Max Harris (b.1921)

and D. B. Kerr, is published in Adelaide, South Australia. Under wartime paper restrictions only one issue may be produced each year.

August–September	*Contemporary Art Society Annual Exhibition*, National Gallery of Victoria. Following the recent internal split the show is predominantly modernist in intention, if not realization.
September	***A minority Conservative Government retains power following Federal elections.***
September–October	*Contemporary Art Society Interstate Exhibition*, David Jones Gallery, Sydney.

Albert Tucker's studio,
Little Collins Street,
Melbourne, c. 1940

1941

January Albert Tucker and Joy Hester marry, moving later in the year to live in a corrugated-iron shed near Heide. Wearying of metaphysical surrealism, Tucker concentrates on developing a new more direct format reflecting his experience of Melbourne life, charged with an air of sexual menace.

Nolan moves to a new studio in Russell Street. Having returned to Melbourne, Counihan is struggling with T.B. Largely a graphic artist, he now commits himself to painting, renting a studio in the same building as Nolan. Bergner and O'Connor

83

join the army and are stationed in rural Victoria.

Max Harris visits Melbourne. After meeting Reed and Nolan, Harris considers forming an alliance between the Angry Penguins group and the Contemporary Art Society.

May

Boyd joins the army. Requesting a transfer to the Survey Corps in Swanston Street (opposite the National Gallery of Victoria), he works in the cartographic section with another painter, John Perceval (b.1923).

The Contemporary Art Society applies for exhibition space at the National Gallery of Victoria. Having sided with the pro-Cézannists following the Bell-group secession, the Gallery refuses permission.

Boyd meets the painter Yvonne Lennie who introduces him to the Tuckers and Reeds; Nolan separates from his wife and moves into Heide. In Melbourne, O'Connor paints traders and scavengers around the central Victoria Market.

August

Angry Penguins 2 is published including reproductions of works by Nolan and Gleeson. Harris, now the sole editor, announces a commitment to the activities of the Contemporary Art Society.

An official survey of public opinion warns of growing 'disillusionment, disappointment, futility, distrust, disgust, diffidence and indifference which so many possess with regard to politics and society in general, and the War in particular'.

September–October

Contemporary Art Society Annual Interstate Exhibition, David Jones Gallery, Sydney.

October

The Conservatives fall and a new Labor Government is formed after two key parliamentarians cross the floor.

Contemporary Art Society Third Annual Exhibition, Hotel Australia, Collins Street. Representational (i.e. post-impressionist) paintings are banned, the Society now explicitly committing itself to experimental modernism. With 310 works being hung the display is even larger than the 1939 *Herald* exhibition, marking the public emergence of a native modernist movement. Paintings by Vic O'Connor and Donald Friend are jointly awarded the Society's medal, and O'Connor meets Counihan and Bergner at the exhibition. Vassilieff stages a dramatic argument at the opening, accusing Nolan of 'betraying the cause' and bending to naturalism.

Art of Australia exhibition is assembled for an American tour, emphasis being placed on selecting reassuring images of Australia as a pastoral landscape. Flaunting all bounds of accepted taste, the Society hosts a riotous night of 'hot jazz' for 'long-hair intellectuals, swing fiends, hot mommas and truckin' jazz boys' amid the vigorously packed walls of the exhibition.

December

Japanese forces attack the American fleet at Pearl Harbour on 7 December, triggering full war in the Pacific.

1942

Boyd shirks the comparative safety of rural landscape painting to experiment with scenes of human metamorphosis in a frantic, deserted townscape.

February *Singapore surrenders to Japanese forces on 15 February. The invasion of Australia seems imminent. On 19 February in the first foreign assault on Australian soil, a Japanese taskforce attacks Darwin on the North coast.*

March *Japanese land in New Guinea on 8 March.*

General Douglas McArthur arrives in Australia, setting up General Headquarters in Menzies Hotel, corner of Bourke and William Streets (near the Bell art school). Melbourne Cricket Ground is transformed into a central service depot, and 'Camp Pell', the main US military base, is established at Royal Park, a large stretch of parkland between the inner suburbs of Parkville and North Melbourne.

April Nolan is conscripted and stationed in the Wimmera district, North-Western Victoria, being assigned labouring and guard duties; he starts paintings of the arid landscape. Also drafted into the army, Tucker is posted to a rural military hospital to make medical drawings of wounds needing plastic surgery; he briefly attempts painting barrack life. Now living at Heide, Hester draws and writes poetry.

May *'The Brown-out Murders' – Melbourne nears hysteria as three local women are strangled and sexually assaulted during the 'Brown-out' over a period of three weeks. An American GI, Edward Leonski, is eventually apprehended and court-martialled for the murders.*

On 31 May, Japanese submarines enter and attack Sydney Harbour.

June *Battle of Midway, 4 June – Japanese expansion across the Pacific is halted.*

Reed relinquishes his legal practice in order to launch a publishing company with Harris; Bergner concentrates on painting outcasts, both Jewish and Aboriginal.

August *Angry Penguins 3* is published, including poems by Alister Kershaw and paintings by Boyd and Tucker, in addition to cubist work.

Contemporary Art Society Fourth Annual Exhibition, Athenaeum Gallery.

Addled Art, an attack on modernism claiming that Picasso, Matisse and 'the morons of the École de Paris' are the instruments of a Jewish conspiracy, is published by Lionel Lindsay, Director of the National Gallery of Victoria. Surrealism, in particular, is viewed as an attempt to pervert the morals of young Australian women.

September	*Contemporary Art Society Annual Interstate Exhibition*, Education Department Gallery, Sydney.
October	Tucker is discharged from the army; Reed assists him with a weekly stipend in order to free him for more painting. O'Connor joins the Communist Party.
November	*Leonski is hanged in Melbourne by the US Army.*

Reflecting on the Brown-out Murders Tucker reconsiders the theme of predatory nightlife, now incorporating a distinct wartime element into his imagery.

December	*Contemporary Art Society Anti-Fascist Exhibition*, Athenaeum Gallery. An exhibition initiated by Communist members; Nolan's *Dream of a latrine sitter* and Tucker's *Army shower room* deflate the organizers' heroic intentions.

1943

Angry Penguins moves to Melbourne to be jointly edited by Harris and Reed. Increasing in prosperity, Issue 4 contains a full-colour reproduction by Gleeson, in addition to works by Tucker, O'Connor, Counihan, Nolan, and the South Australian surrealist Ivor Francis (b. 1906). Articles include translations of Rimbaud by Sunday Reed and polemical pieces on art and politics: 'Intellectuals of the world unite!' Tucker thunders, 'You have nothing to lose but your brains!' Harry Roskolenko, American poet and visiting GI, contacts *Angry Penguins* offering to establish links with writers in New York.

Perceval and Boyd share a studio. Perceval plays with semi-autobiographical impressions of childhood experience, while Boyd paints lovers and geriatrics locked in desperate embraces. Believing they should loosen their approach to allow 'a free-flow of mind concepts', Vassilieff gives Boyd and Perceval painting lessons; Vassilieff openly starts an affair with Lottie Schumacher, wife of an interned German businessman. Bergner joins the Communist Party.

May	Vassilieff exhibition, Riddell's Galleries.
June–July	*Contemporary Art Society Fifth Annual Exhibition*, Education Department Gallery, Sydney.
August	Nolan exhibition, Contemporary Art Society Studio, Collins Street. Hester's poems are published in *A Comment*.

Australian Present Day Art is published by Sydney Ure Smith. The book is biased towards pastoral landscape and colonial nostalgia, the sole 'modernists' represented being drawn from the post-impressionist milieu.

The Labor Government returns to power in landslide Federal elections.

August–September	*Contemporary Art Society Fifth Annual Exhibition*, Velasquez Gallery, Tye's Furniture Store, Bourke Street.
September	*Angry Penguins 5* is published, and includes works by Hester, Perceval and

Vassilieff; a riposte to *Addled Art*; and attacks on the Angry Penguins group from Counihan and Harry de Hartog.

A major disagreement on the direction of the Contemporary Art Society surfaces between the Angry Penguins and Communist members lead by Bergner, Counihan and O'Connor.

October–November	*Contemporary Art Society Fifth Annual Exhibition*, North Terrace, Adelaide.

Last Japanese air raid on the Australian North Coast on 12 November.

Max Harris and Joy Hester in a Melbourne milk bar, c. 1944

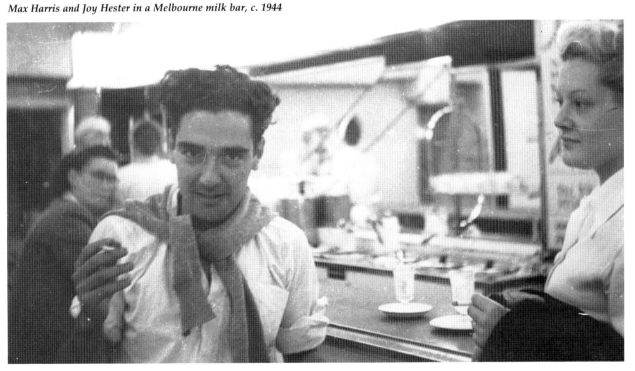

1944

February	Nolan is transferred to Watsonia Barracks (just 2 miles from Heide), awaiting posting to the front line in New Guinea; O'Connor is demobbed. Having fully evolved his own personal surrealist vocabulary, Tucker undertakes his *Images of Modern Evil* – bitter pessimistic paintings of moral decay glimpsed in the urban night. The series is recognizably set in the bayside suburb of St Kilda where 'teenage girls could be bought for a few shillings'.
March	Boyd and Perceval are discharged from the army. John Perceval marries Mary Boyd; to assist with his painting, the Reeds also pay Perceval a regular stipend.
April	Leading the communist bloc, Bergner, Counihan and O'Connor lobby to divert the direction of the Contemporary Art Society from avant-garde radicalism.

Helen MacDonald leaves Vassilieff. After several half-hearted suicide attempts Vassilieff ceases work on his urban impressions, now channelling his emotions into a series of agonized expressionist paintings. Tucker and Hester spend considerable time with Vassilieff at Stonygrad.

Angry Penguins receives a manuscript of unpublished surrealist work by Ern Malley, an unknown poet who had succumbed to Graves's disease. Harris, Reed and Nolan decide to publish a special section dedicated to the poet in *Angry Penguins 6*; also included are responses to Harris's novel *The Vegetative Eye*, communist attacks on surrealist principles, and an examination of Aboriginal art by Tucker.

June	The 'Ern Malley' poems are revealed to be a hoax. The writer proves to be no more than a bogus surrealist concocted by James McAuley and Harold Stewart, anti-modernist poets with an axe to grind: 'We opened books at random, choosing a word or phrase haphazardly. We made lists of these and wove them into nonsensical sentences'.

Vassilieff warns Tucker and Reed that the communists have prepared to take over leadership of the Contemporary Art Society. Never having been happy with CAS politics, Counihan and Bergner see the 'Ern Malley' crisis as an opportunity to destabilize the ruling Angry Penguins group. Following annual elections the Angry Penguins retain control by a single vote.

June–July	*Contemporary Art Society Sixth Annual Exhibition*, Education Department Gallery, Sydney.
July	Nolan deserts from the army and hides in a Parkville stable-come-studio which he later shares with Harris.
September	*Contemporary Art Society Exhibition*, Velasquez Gallery. Vassilieff and Boyd exhibit their new work in a mature expressionist mode.

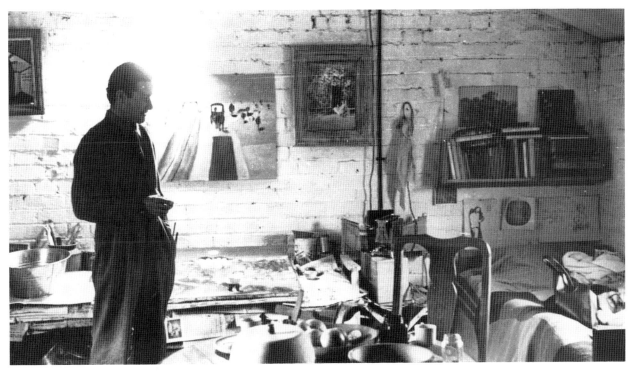

Sidney Nolan in his studio loft in Parkville, 1945

In the wake of the 'Ern Malley' hoax, Harris is prosecuted by the authorities in South Australia for publishing indecent material.

December *Angry Penguins 7* is published. Over half the magazine deals with the 'Ern Malley' crisis, arguing that the poems are better than their authors realize and pointing out that surrealist practices were used to compose the pieces. Herbert Read leads the many defenders of the poems' worth, while Counihan is highly critical of Reed, Harris, Nolan and Tucker. Also included

are works by Boyd, Perceval, Vassilieff, an *Image of Modern Evil* by Tucker, and an article on the naive paintings of 'H.D., an unknown Australian Primitive'.

Vassilieff retrospective exhibition, Velasquez Gallery; Lottie Schumacher moves into Stonygrad.

Seriously depressed rural Victoria suffers under the combined forces of wartime rationing and blistering drought.

In Sydney, Drysdale plans to paint the exhaustion of the land.

1945

Nolan moves to Heide, switching his painting from bleached Wimmera landscape themes to more idyllic images from his youth in the bayside suburb of St Kilda.

February

Joy Hester gives birth to a son, Sweeney.

Australian Present-Day Art exhibition, Melbourne Town Hall. Assembled by *Herald* art critic Clive Turnbull, the selection begrudgingly acknowledges the presence of the social realist and Angry Penguins groups.

March

Arthur Boyd marries Yvonne Lennie; Nolan produces his first *Kelly* painting based on the story of Ned Kelly, last of the Bushrangers and now a mythic folk-hero (Kelly's armour was housed in the St. Kilda Aquarium).

Communist critic Bernard Smith publishes *Place, Taste and Tradition: A Study of Australian Art from 1788*. The first analytic history of Australian art, Smith's text is based on Contemporary Art Society lectures delivered between 1941–43, his thesis being that local contemporary painting is both fundamentally democratic, and directed toward establishing a new expressive realism.

May

VE Day, 8 May; Germany unconditionally surrenders.

July

John Curtin dies, Ben Chifley (an ex-locomotive driver) replacing him as Labor Prime Minister.

By far the longest issue, *Angry Penguins 8* runs to over 180 pages in length. It includes innovative sections on both film and sociology, an article by Sidney Janis on contemporary American art, Boyd's recent landscape paintings, and a discussion of Chinese and Japanese art.

August

Atom bomb detonated over Hiroshima on 6 August; three days later a second is dropped on Nagasaki.

VJ Day, 14 August; Japan surrenders. Melbourne erupts into a joyous city-wide celebration.

Contemporary Art Society Exhibition, Myer Gallery, Myer Emporium, Bourke Street. The shocked management order that Boyd's 'obscene picture' *Two Lovers (The Good Shepherd)* be removed from the show.

Nolan returns to painting goldfields and Western District landscapes; communist leadership demands that Bergner depict the noble figure of the worker. Bergner breaks with the Communist Party.

November

Contemporary Art Society Exhibition, Sydney.

1946

Disappointed with the direction of Reed-Harris publishing, Tucker formally breaks with *Angry Penguins* magazine; Bergner attends classes at the National Gallery School.

From January a new *Angry Penguins Broadsheet* edited by Harris, McGuire, and later Nolan, is published monthly. Usually under ten pages in length, by June the broadsheet consists mostly of articles posted from contacts in America. Henry Miller and Jean-Paul Sartre are just two of the names replacing local content.

Nolan and Harris travel through central Victoria – 'Kelly Country' – the main Kelly paintings dating from this time until May 1947; Boyd's paintings move into the depiction of a moral Victorian landscape with explicit Biblical allusions. After placing the shell of a cable tram on top of his home, Vassilieff declares his patchwork-dwelling Stonygrad finally completed.

July Nolan, Tucker and Boyd exhibition, Rowden White Library; *Three Realist Artists*: Counihan, O'Connor and Bergner exhibition, Myer Gallery.

September *The Labor Government is returned with a 53% vote, and announces the establishment of a post-war immigration programme.*

October Succumbing to crippling financial losses a modest 64 page *Angry Penguins 9* is published. With the radical modernist group now dispersed, Harris is the sole Angry Penguin with work in the issue, his editorial speaking of 'post-war disillusionment' and the rapid emergence of a new artistic 'hierarchy'.

Contemporary Art Society Eighth Annual Exhibition. The exhibition reflects and confirms the cultural malaise already lamented by Harris.

November *Contemporary Art Society Eighth Annual Interstate Exhibition*, Education Department Gallery, Sydney.

Vassilieff spends time in Sydney, while Nolan stays at Stonygrad working on his Kelly series.

December The final *Angry Penguins Broadsheet* edited by Harris and Harry Roskolenko is published. With a cover photograph of Harlem's Morris Goode jamming with Melbourne's Roger Bell, *Angry Penguins* features the last major artistic exchange with visiting GIs – Australia's first Jazz Convention. Following the edition Harris resigns from the Reed-Harris partnership and returns to Adelaide, while the Reeds spend summer holidaying in Queensland.

1947

The Melbourne branch of the Contemporary Art Society of Australia is disbanded; Nolan leaves Melbourne for Queensland via Sydney; Tucker and Hester separate, Tucker leaving Australia for Japan in February.

March Danila Vassilieff marries Elizabeth Hamill, an attractive young heiress.

April Exhibition of Nolan's *Ned Kelly Paintings 1946-7*, Velasquez Gallery.

Vassilieff exhibition, Myer Gallery. Vassilieff starts sculpting small Vorticist-like figurines from locally-mined marble.

Impressed with recent colour reproductions of Tintoretto paintings, Boyd and Perceval extend their work on Biblical motifs sited in the local landscape.

Hester starts a relationship with painter Gray Smith, before discovering she has Hodgkin's disease and is given two years to live. She allows Sweeney to be adopted by John and Sunday Reed. Begins the *Face* series of drawings.

Tucker returns briefly to Melbourne before leaving for Europe; Bergner leaves Melbourne for Paris.

1948

Perceval ceases painting to work in ceramics for eight years; Boyd travels through the Wimmera working on a new series of landscape images; Hester starts the *Sleep* series; Vassilieff begins illustrating children's stories with gouache and watercolour.

Before the War **Sidney Nolan** had been barely more than a knock-about youth from an Irish background (surviving on fragmentary work as a tram conductor, dishwasher, and display designer in a hat factory), but with his first *Kelly* exhibition Nolan was unmistakably the brilliant *enfant terrible* of Australian art. He remained very much a narrative painter, his trip to Frazer Island in Queensland maturing into the *Eliza Frazer* paintings (1947-48, 1962-64), detailing the tale of a shipwrecked European woman. Following his marriage to the novelist Cynthia Reed (John Reed's sister) in March 1948, Nolan concentrated on painting the Australian goldfields and awesome desert landscapes for several years, the couple making regular trips through the outback. In 1955 they moved to London where Nolan produced further *Ned Kelly* works (1955-57, 1962-64), followed by *Leda and the Swan* (1959-60), the explorers *Burke and Wills* (1961-62), *Gallipoli and the Anzacs* (1959-63) and the *Antarctica* series (1964). Cynthia Nolan died in 1976. Sidney Nolan has since married Mary Boyd.

Relieved to be 'finished with Australia' **Albert Tucker** painted and exhibited his way through France, Italy, Holland and Britain, followed by New York and Mexico. He returned to Melbourne in 1960, evolving a potent new symbol, *The Antipodean Head* – the craggy, fissured, husk-like visage of middle Australia. Tucker remained anything but a 'delicate' aesthete. Through the 60s he painted a vicious country where exotic birds picked at gum trees peeling into scabs, and where, later, gargoylish convicts hounded each other across a hopeless fracturing desert.

The *Berwick* and *Wimmera* landscapes of 1948-49 won **Arthur Boyd** the respect of Australia's cultural establishment, and he continued exploring landscape motifs travelling through the Central Australian desert in 1953. In 1956-57 Boyd painted his Chagall-like *Love,*

Marriage and Death of a Half-Caste (often called *The Bride* series), an allegorical group on the life of a part-Aboriginal stockman, which brought him to international attention. After moving to London in 1960 his work often centred on the metamorphosis of a spectral moon-faced nude in a melancholy forest clearing. Since the 70s Boyd has divided his time between Britain, Tuscany, and the Shoalhaven River in New South Wales.

Joy Hester's illness went into remission in 1948, although her ink-and-brush drawings and her poems still conveyed the restrained *fleurs du mal* mood accompanying her most troubled moments. 1950 brought the joy of her first solo exhibition and the pain of miscarrying twins. She gave birth to a son, Peregrine, in March 1951, and a daughter, Fern, in September 1954. The following year Hester's condition began to deteriorate and she gradually drew and wrote less. By 1959 her divorce from Tucker was finalized and she married Gray Smith in March; however, she now had to spend lengthy periods in hospital. Joy Hester died on 4th December 1960.

John Perceval spent ten years assisting in rehabilitating the Boyd family pottery. He exhibited a number of Breughel-inspired paintings in 1954, but much of his time was spent experimenting with ceramic 'angels' – small joyous putti tumbling over each other. In the 1960s he returned to painting, with frenzied bush and seascapes, characteristically populated with heaving trees, static waves, rolling ships and figures disappearing into tumbling pigment. Perceval has painted intermittently since the mid-70s.

Danila Vassilieff was forty when he arrived in Melbourne, having led a restless life across five continents (he had served at the Front during the First World War; joined the Don Cossack army to fight the Bolsheviks; escaped across Asia; laboured on a railway in

Northern Australia; been foreman for an oil company in Rio; and made his way through the galleries of Europe) while teaching himself painting. After marrying Elizabeth Hamill at the age of forty-nine he had hoped to settle down, but their relationship was breaking down by 1952. During this time Vassilieff worked with ever increasing energy creating his most poetic gouaches and sculptures, particularly the paintings *Peter and the Wolf* (1948) and *Mildura* (1954-57). He strongly believed in the value of children's art, joining the Melbourne Education Department and refusing to follow the rigid art syllabus. By late 1957 with 'a car full of paintings', little money, poor health, no job and no home, he was still cheerfully quarrelling with friends about art. Danila Vassilieff suffered a heart attack and died on a visit to Heide in March 1958.

Noel Counihan continued to build on his reputation as a painter of heroic work, sweat and struggle after the War, although like most 'political' artists his work was temporarily eclipsed during the confident 'philistine years' of the 1950s. Counihan emerged into the limelight once again when Australia entered the Vietnam War in the 60s, producing some of the most potent painting and graphic work associated with the protest movement. In addition to direct commentaries on war Counihan also developed *The Good Life* and *Laughing Christ* images – biting views of Australia's false morality. He died in 1986.

After the wild years of the 40s **Vic O'Connor** established a reputation as a painter of clear light landscapes, travelling to England in the early 1970s.

Likewise **Yosl Bergner** ceased to paint with the nervous energy of the war years. Originally raised in highly-cultivated Jewish intellectual circles, Bergner returned to peacetime Europe where a refined, less-anxious painterly style emerged. He studied in Paris for two years before deciding to settle permanently in Israel.

An enthusiastic response from the visiting art historian Sir Kenneth Clark led **John** and **Sunday Reed** to take Nolan's *Kelly* series to Paris in 1948 for an exhibition at UNESCO. In Melbourne the couple continued to encourage and support young local artists, being instrumental in setting up a private Museum of Modern Art and Design (1958-66). As the Museum's Director John Reed was able to exhibit art shunned by the conservative art scene; he also organized a grant to assist Albert Tucker in returning to Australia. In 1977 the Reeds gave part of their collection of paintings (including the first *Kelly* series) to the Australian National Gallery, Canberra. Heide and the remaining works were sold to the Victorian government for development as a public gallery in 1979. John Reed died in December 1981, Sunday Reed died a short time later.

On returning to Adelaide **Max Harris** continued writing and publishing poetry. He went on to create and edit a number of literary magazines including *Ern Malley's Journal* (1952-55), *Australian Letters* (1957-68) and *Australian Book Review* (1961-74). Harris has also been a proprietor of the influential Mary Martin Bookshop and a director of Macmillan Australia.

Albert Tucker on the Left Bank, Paris, 1951

SELECT BIBLIOGRAPHY

Adams, Brian, *Sidney Nolan: Such is Life, A Biography,* Hutchinson, Melbourne, 1987.

Aloni, Nissim, and **Rodi Bineth-Perry,** *Yosl Bergner, Paintings 1938–1980,* Keter, Jerusalem, 1981.

Australian National Gallery, *Sid Nolan's Ned Kelly,* Canberra, 1985.

Burke, Janine, *Joy Hester,* Greenhouse, Melbourne, 1983.

Clark, Jane, *Sidney Nolan: Landscapes and Legends,* ICCA, National Gallery of Victoria, Melbourne, 1987.

Clark, Kenneth, Colin MacInnes and Bryan Robertson, *Sidney Nolan,* Thames and Hudson, London, 1961.

Dimmack, Max, *Noel Counihan,* Melbourne University Press, Melbourne, 1974.

Dixon, Christine, and **Terry Smith,** *Aspects of Australian Figurative Painting 1942–1962: Dreams, Fears and Desires,* Power Institute of Fine Arts, Sydney, 1984.

Gunn, Grazia, *Arthur Boyd: Seven Persistant Images,* Australian National Gallery, Canberra, 1985.

Haese, Richard, *Rebels and Precursors: The Revolutionary Years of Australian Art,* Allen Lane, Melbourne, 1981.

Harris, Max, 'Angry Penguins and After' *Quadrant* 7.1 (1963).

Hoff, Ursula, *The Art of Arthur Boyd,* André Deutsch, London, 1987.

Hughes, Robert, *The Art of Australia,* rev. edn. Penguin Books, Harmondsworth, 1970.

Lynn, Elwyn, *Sidney Nolan – Australia,* Bay Books, Sydney, 1979.

McCulloch, Alan, *Encyclopedia of Australian Art,* 2 vols., Hutchinson, Melbourne, 1984.

McQueen, Humphrey, *The Black Swan of Trespass: The Emergence of Modernist Painting in Australia,* Alternative Publishing Co-Operative, Sidney, 1979.

Merewether, Charles, *Art & Social Commitment: An End to the City of Dreams 1931–1948,* Art Gallery of New South Wales, Sidney, 1983.

Mollison, James, and **Nicholas Bonham,** *Albert Tucker,* Macmillan, Melbourne, 1982.

Moore, Felicity, *Vassilieff and his Art,* Oxford University Press, Melbourne, 1982.

National Gallery of Victoria, *Rebels and Precursors: Aspects of Painting in Melbourne 1937–1947,* Melbourne, 1962.

—, *Noel Counihan: Paintings, Drawings, Prints 1943–1973,* Melbourne, 1973.

—, *Sidney Nolan: The City and the Plain,* Melbourne, 1983.

—, *Yosl Bergner, A Retrospective,* Melbourne, 1985.

Phillip, Franz, *Arthur Boyd,* Thames and Hudson, 1967.

Plant, Margaret, *John Perceval,* Lansdowne, Melbourne, 1971.

Reid, Barrett, 'Joy Hester, Draughtsman of Identity.' *Art and Australia* 4.1 (1966) 45–53.

DANILA VASSILIEFF

Danila Vassilieff
Nocturne no 3, Commonwealth Lane
1936
Art Gallery of New South Wales,
Sydney
No.1

98

Danila Vassilieff
Theatre party
1944
Mr and Mrs Alan Geddes
No.4

Danila Vassilieff
Street scene with graffiti
1938
Private collection, Melbourne
No.2

100

Danila Vassilieff
Girl and boy in Fitzroy
c.1945–46
Australian National Gallery, Canberra
No.5

SIDNEY NOLAN

Sidney Nolan
Kiata
c.1943
Australian National Gallery, Canberra
No.10

Sidney Nolan
Bathers
1943
Heide Park and Art Gallery, Melbourne
No.11

Nolan spent the first nineteen years of his life in the Melbourne seaside suburb of St Kilda. The beach and St Kilda swimming baths were Nolan's haunts as he grew up. The pier, amusement parlours, esplanade and gardens provided working-class entertainment by day, with 'cafés, dance halls and Luna Park at night.'

Sidney Nolan
Ned Kelly
1946
Australian National Gallery, Canberra
No.25

The story of Ned Kelly is familiar to Australians: with brother Dan and friends Joe Byrne and Steve Hart, the bushranger of Irish parentage was hunted through north-eastern Victoria in the late 1870s, outwitting the police. Despite home-made armour he was captured at Glenrowan and hanged at Melbourne Gaol on 11 November 1880 at the age of twenty-five, his last words being 'Such is life'. His reputation varies from revolutionary hero to murdering criminal. Kelly was active at a time of great tension between rich landowners and settlers who wished to unlock the land, and in part was persecuted by police because of his class position. He recognized the problem, and the 'Jerilderie letter' was both a protest and a virtual call to civil war.

Opposition to authority has been seen as an Australian national trait, and Ned

Sidney Nolan
Death of Sergeant Kennedy at Stringybark Creek
1946
Australian National Gallery, Canberra
No.33

Kelly symbolizes both the rebel and the gallant failure. The Irish heritage of a third of the population is another factor, complicated by the fact that not only the despised 'traps' (the police), but also the outlaws were mostly Irish. Sidney Nolan's grandfather told stories of his time as a policeman at Beechworth when the Kelly gang was ranging there.

In 1946 Nolan travelled to 'Kelly country' with Max Harris, writer and editor of *Angry Penguins*, and saw Ned Kelly's younger brother Joe. The artist was fascinated with the morally equivocal figure of Kelly and started painting the first works on a theme to which he has returned throughout his career. As well as historical and cultural questions – Australia's past was not regarded as the stuff that made art, and until the War modernism had virtually ignored national

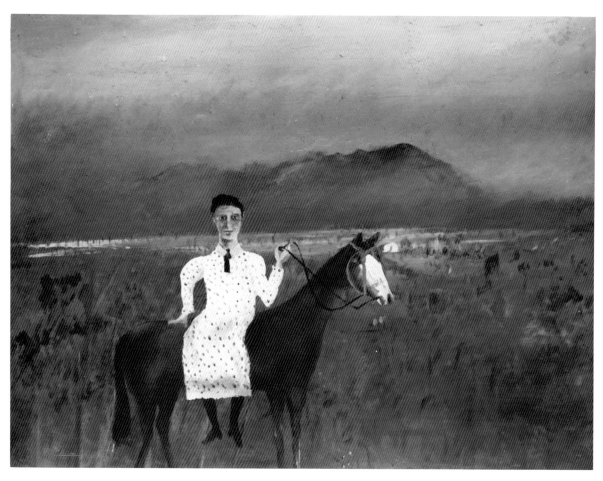

Sidney Nolan
Steve Hart dressed as a girl
1947
Australian National Gallery, Canberra
No.30

tradition, especially a populist one – Nolan addressed his own personal situation: 'It's an inner history of my own emotions', he said in 1984.

Nolan's paintings were accompanied by brief quotations chosen from two sources: the 1881 *Report of the Royal Commission* on the Victorian Police Force and its pursuit of the Kellys, and J. J. Kenneally's *Complete Inner History of the Kelly Gang and their Pursuers*, first published in 1929. An added narrative commentary therefore connects the works. The defeat of Kelly and his death on the scaffold is not depicted by Nolan, perhaps because he wished to show Kelly, if not triumphant, then at least morally equal to his enemies in the stand-off of the courtroom.

The brilliance and bravura of the twenty-seven Kelly paintings of 1946–47

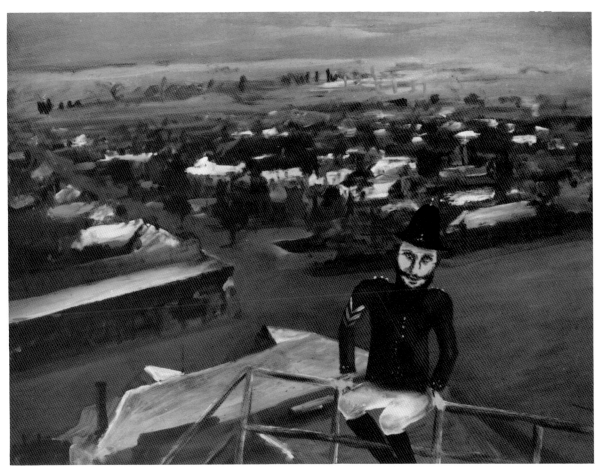

Sidney Nolan
The watch-tower
1947
Australian National Gallery, Canberra
No.34

have seldom been equalled by Nolan. Visual invention is combined with poetic sensibility to produce a group of works which portray figures in a landscape with a unique vision. The Australian bush is more than the setting for a human drama, it is a participant in the story. Nolan felt the bush was 'the most real aspect of life, because of the smell and the light and everything else.' The medium he chose to use for its depiction was Ripolin, a commercial enamel paint, on composition board. Ripolin's qualities of fluidity and density allow the bright, opaque colours to blend or be superimposed as needed.

Kelly's helmet, a simplified and usually abstracted black form, has an uncanny presence. Although only seen in thirteen of the works, that is, less than half, it dominates these paintings. Highly decorative motifs float through the

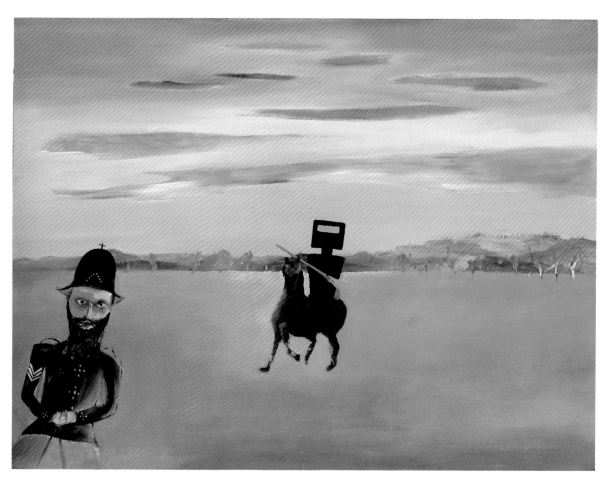

Sidney Nolan
The encounter
1946
Australian National Gallery, Canberra
No.37

images, particularly in the interior scenes. In *The trial* the relentless red and white of the diamond-shaped floor tiles are repeated in the judge's wig and robes.

The *faux naif* style employed by Nolan in the Kelly paintings disguises a sophisticated aesthetic schema. Even the humour was misleading to some – for example, the cowardice of the police in the *Defence of Aaron Sherritt* (1946) and *The encounter* (1946). Nolan commented in 1984: 'Many of the policemen did not want to encounter the Kellys. Kelly was a wrathful myth in his own day and the frightened policeman got out of the way in the corner of the painting and gave Kelly centre stage . . .'

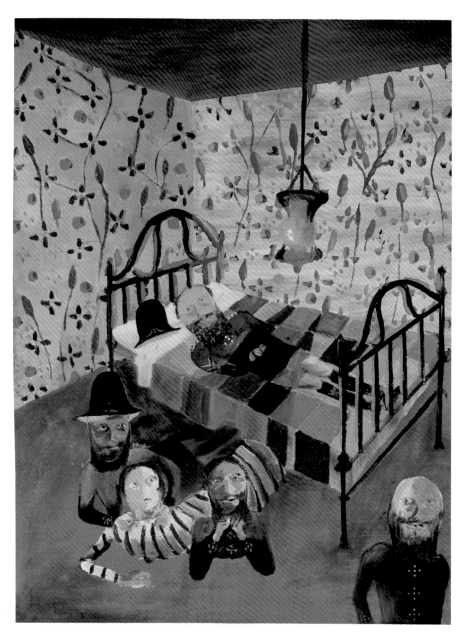

Sidney Nolan
Defence of Aaron Sherritt
1946
Australian National Gallery, Canberra
No.39

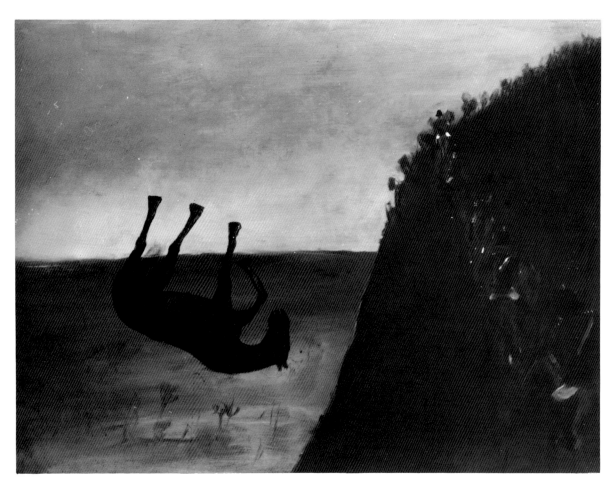

Sidney Nolan
The slip
1947
Australian National Gallery, Canberra
No.43

110

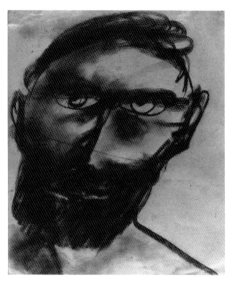

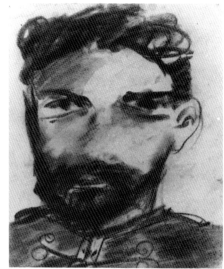

Sidney Nolan
Bushranger's head
c.1947
Australian National Gallery, Canberra
No.49

Sidney Nolan
Bushranger's head
c.1947
Australian National Gallery, Canberra
No.51

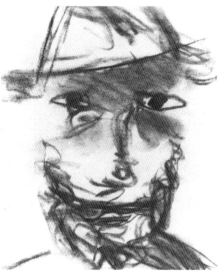

Sidney Nolan
Bushranger's head
c.1947
Australian National Gallery, Canberra
No.52

Sidney Nolan
Bushranger with mask
c.1947
Australian National Gallery, Canberra
No.53

111

Sidney Nolan
The trial
1947
Australian National Gallery, Canberra
No.48

ALBERT TUCKER

Albert Tucker
Spring in Fitzroy
1941
Australian National Gallery, Canberra
No.55

Albert Tucker
Pick-up
1941
Australian National Gallery, Canberra
No.56

Albert Tucker
Death of an aviator
1942
Australian National Gallery, Canberra
No.60

Two works entitled *Spring in Fitzroy* exemplify Tucker's disparate output during the War. The first, from 1941, stylistically and politically has something in common with social realism. The second work, painted in 1943, borrows elements from abstract art (and especially Picasso), in attempting a modernist, syncretic interpretation of personal and wider questions.

Tucker's eventual absorption of surrealism led to more sophisticated works, but the rawness of the wartime paintings, with their violent colour, has much expressive power. *Pick-up* (1941), with its virulent greens and bestial masks of

Albert Tucker
Image of Modern Evil: Spring in Fitzroy
1943–44
Australian National Gallery, Canberra
No.62

faces, has sources in the work of Grosz, Beckmann and Dix. The fearsome women, with their diaphanous clothes, are sexual predators as well as objects of lust.

Death of an aviator (1942) uses distortion and compression of space in a frightening anti-heroic work. Viktor Löwenfeld's book *The Nature of Creative Activity*, translated into English in 1939, categorized rational 'visual' and subjective 'haptic' perception and impressed Tucker deeply. 'Haptic' creation, projecting the artist's inner world into the picture, allowed the depiction of different times in one image and implied a direct emotional response to experience.

Albert Tucker
Sunbathers
1944
Australian National Gallery, Canberra
No.64

Albert Tucker
Image of Modern Evil 14
1945
Australian National Gallery, Canberra
No.78

Albert Tucker
Image of Modern Evil 25
1946
Australian National Gallery, Canberra
No.85

119

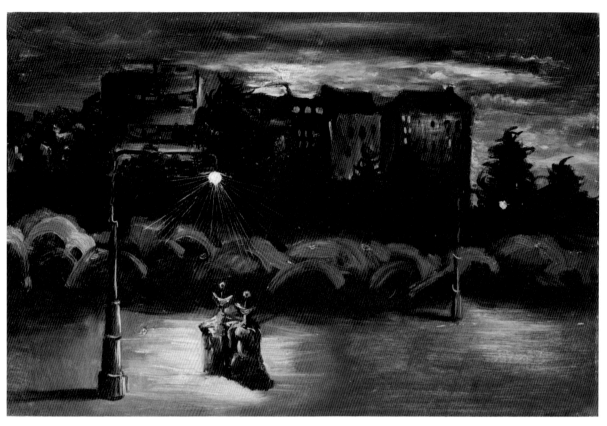

Albert Tucker
Image of Modern Evil 15
1945
Australian National Gallery, Canberra
No.79

The group of paintings known as *Images of Modern Evil* has an alternative, more neutral name: *Night images*. The moral and political dimensions of the first title are overt, especially in the particularity of 'modern' – that is, Australia during the Second World War. Tucker's depiction of the public/secret nocturnal world of the inner city is shocking, grotesque and emotive. Imagery of sexuality and violence is intertwined; its location in familiar surroundings accentuates the horror.

Virginia Spate has pointed out that the huge influx of American troops 'was perceived by many as a sexual invasion. This was a fear in which nightmare and

Albert Tucker
Victory girl
1943
Australian National Gallery, Canberra
No.90

reality intermingled . . . the unleashing of a monstrous sexuality . . . a sexual
takeover of the city. It was sexuality, including black sexuality, which colours the
paintings of war-time Melbourne.' Tucker's intensity, like Perceval's, comes from
the manipulation of light and extremity of colour. His debt to Grosz, Beckmann
and other painters of the *Neue Sachlichkeit* is apparent, but like other Australian
artists of the time he manages to transform his sources, adding the vigour and
power of new, imaginative truths to observed social reality.

Albert Tucker
Female figure with tents and moon
1943
Australian National Gallery, Canberra
No.92

Albert Tucker
Study for Image of Modern Evil 23
c.1944
Australian National Gallery, Canberra
No.95

ARTHUR BOYD

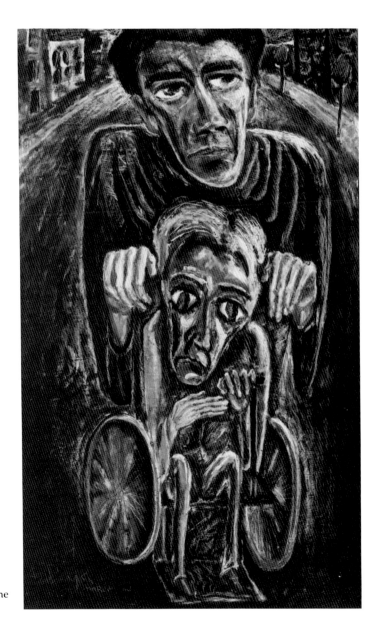

Arthur Boyd
Progression
1941
Heide Park and Art Gallery, Melbourne
No.98

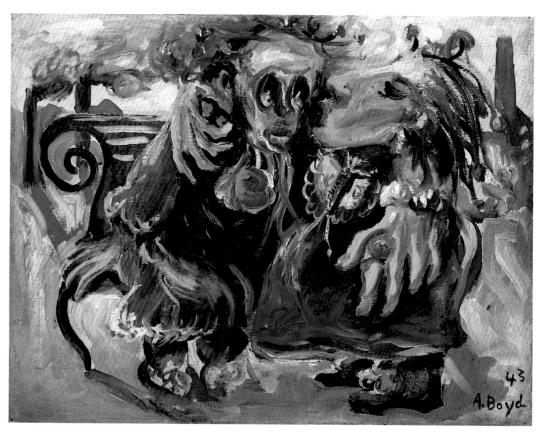

Arthur Boyd
Lovers on a bench
1943
Australian National Gallery, Canberra
No.101

The obsessive realm of lovers and cripples created by Boyd in Melbourne between 1943 and 1945 has an urban setting for its expositions of anxiety, passion and guilt. The suburban streets with their factories, houses and trees, cemeteries and park benches are characters in dramas of loss and redemption. People, animals, even plants are transmogrified, constantly depicted in the act of metamorphosis.

When Boyd worked in the Army Survey Corps in 1943–44, he was stationed

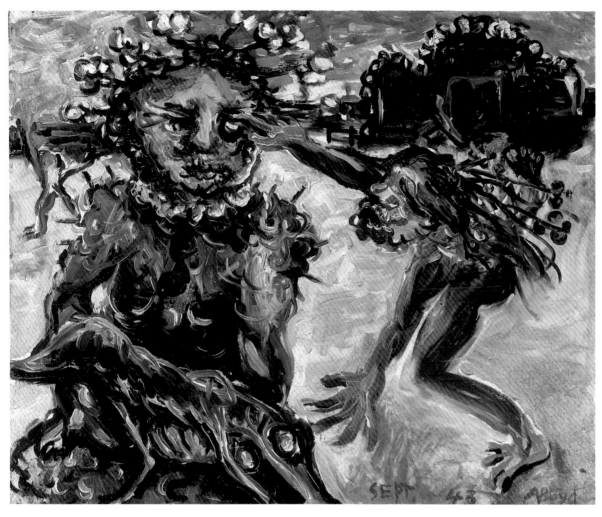

Arthur Boyd
The baths (South Melbourne)
Australian National Gallery, Canberra
No.100

in the inner-city bayside suburb of South Melbourne. It was a very poor, depressed area of run-down Victorian terrace houses, populated by the elderly, with maimed ex-soldiers haunting the beach. Where Tucker depicted social decay in terms of sexual violence, Boyd was more equivocal, perhaps seeing lovers as redeemers of society, as the physically crippled become emotional and moral symbols in his iconography.

Arthur Boyd
The gargoyles
1944
Australian National Gallery, Canberra
No.105

126

Arthur Boyd
Two lovers (The Good Shepherd)
1944
Heide Park and Art Gallery
No.111

Arthur Boyd
Melbourne burning
1946–47
The Robert Holmes à Court Collection
No.113

Arthur Boyd
The mining town
*c.*1946–47
Australian National Gallery, Canberra
No.114

The sweeping expressive strokes and often lurid colour that Boyd used to convey his sense of emotional and social urgency changed in the mid-1940s when he approached new and less specific topics. An accumulation of imagery from his South Melbourne paintings was combined with reprises of European tradition. He studied reproductions of Rembrandt, Bosch and Breughel, digesting the richness of colour as well as effects of oil paint and egg tempera.

By harnessing certain elements to his needs, Boyd created a syncretic vision

Arthur Boyd
*Study for the painting The Kite
(Crucifixion)*
*c.*1943
Australian National Gallery, Canberra
No.121

Arthur Boyd
Cripple in smoke from factory chimney
1942
Australian National Gallery, Canberra
No.117

130

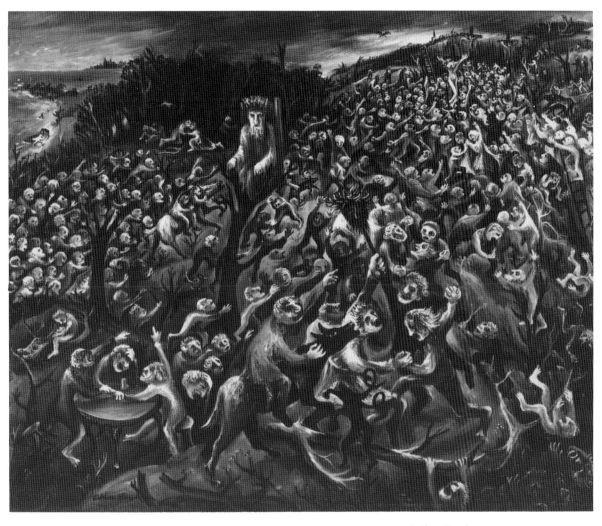

Arthur Boyd
The mockers
1945
Art Gallery of New South Wales,
Sydney
No.112

in his biblical scenes set around Melbourne. After Belsen and the atomic bomb, an ethical desert existed, which he transformed into the Apocalypse of *The mockers* (1945) and *Melbourne burning* (1946–47). *The mining town* (1946–47) has the subtitle *Casting the money-lenders from the temple.* The overall frenzy of other religious pieces has diminished, the action forming part of a 'landscape of seasonal human activity.'

JOHN PERCEVAL

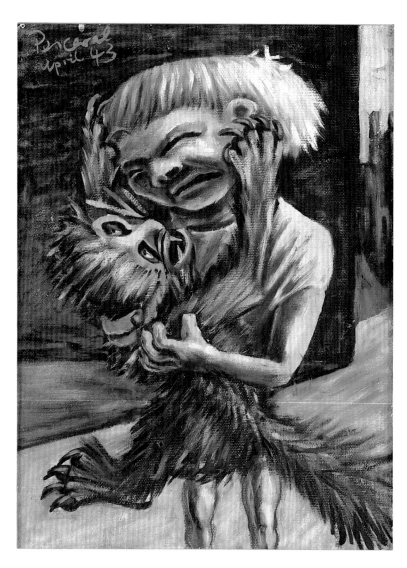

John Perceval
Boy with a cat
1943
Australian National Gallery, Canberra
No.125

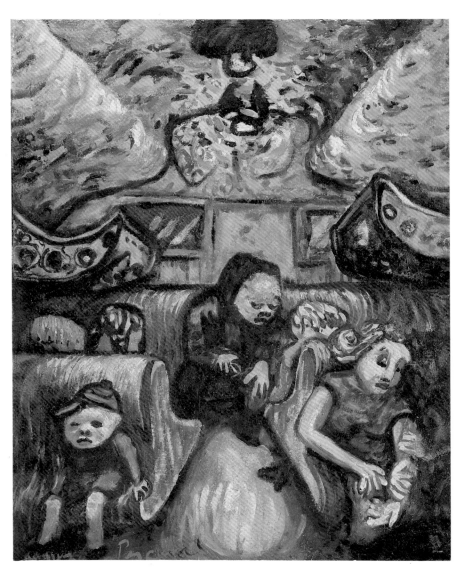

John Perceval
Black-out train
1943
Mr M. J. Dougherty
No.127

133

John Perceval
Boy crying in a Carlton street
1944
The artist
No.129

134

John Perceval
Waiting at Murrumbeena Station
1944
The artist
No.130

A constant preoccupation for Perceval is the psychological state of people alone or *en masse*. A small blond boy appears often, in recollection of the artist's own unhappy early experiences, seemingly threatened by forces beyond his control.

Perceval's psychological dramas dominate this period, especially in the works based on observation of wartime Melbourne, such as *Flinders Street at night* and *Black-out train* (both 1943). Significantly, the night settings allow the subconscious world of dreams and nightmares to escape, transforming the images from depictions of literal reality to those of painful emotional truths.

135

John Perceval
Flinders Street at night
1943
Private collection, Sydney
No.128

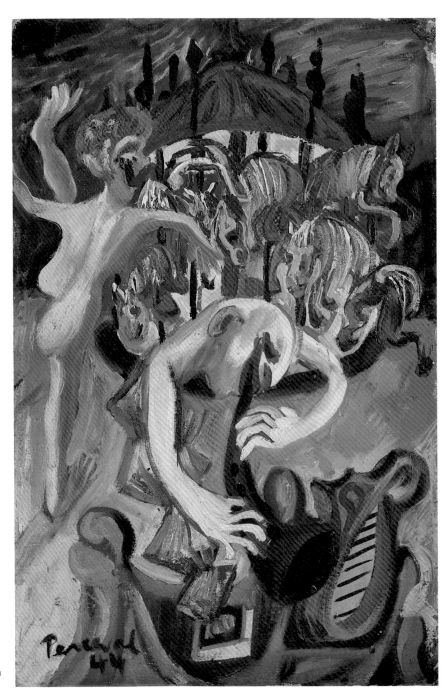

John Perceval
The merry-go-round
1944
Australian National Gallery, Canberra
No.131

137

John Perceval
Landowner watching the shearer work
1942
Australian National Gallery, Canberra
No.138

John Perceval
Horse attacking a man
1944
Australian National Gallery, Canberra
No.142

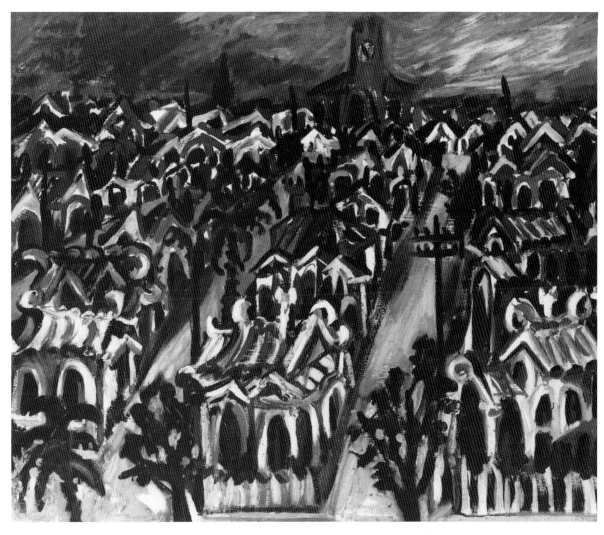

John Perceval
Suburban roofs at night
1944
Heide Park and Art Gallery, Melbourne
No.132

Until the end of the War Perceval pictured an inhabited urban landscape.
Surburban roofs at night (1944) is an exception – humans are missing, and the
houses take on an uncanny life of their own. It is the banal (with its unexpected
edge) that is the artist's concern, relatively new subject matter in Australian art.
The Russian émigré Danila Vassilieff introduced the theme in his street scenes of
the 1930s, and his interest in children's art also influenced Perceval and Boyd.

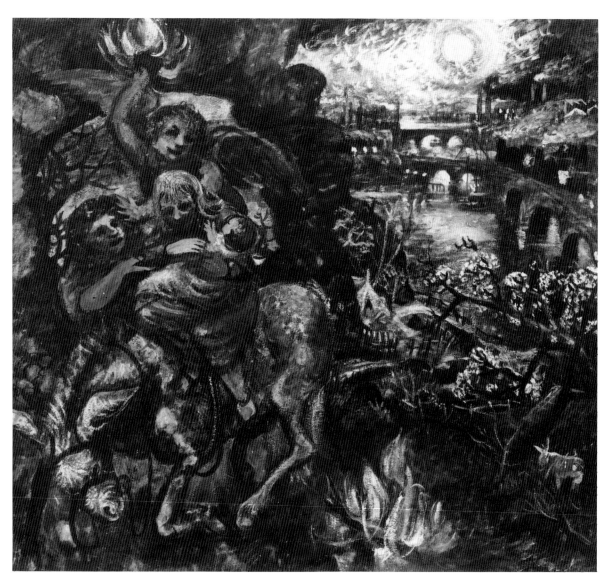

John Perceval
Flight into Egypt
1947–48
Art Gallery of Western Australia, Perth
No.136

140

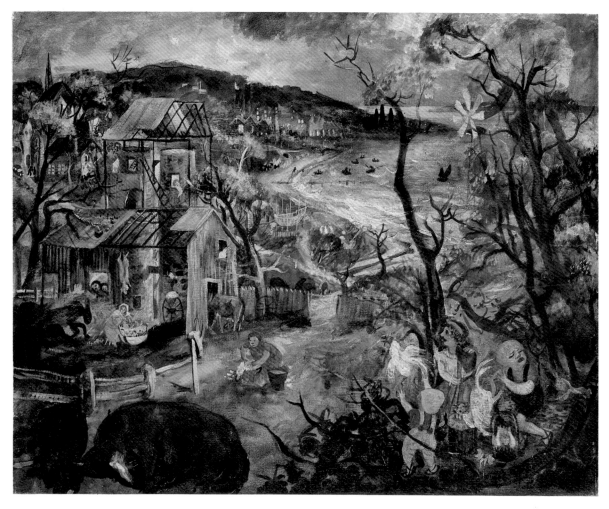

John Perceval
Christmas Eve
1948
The artist
No.137

New kinds of emotion were expressed in Perceval's post-war works. Like Boyd, Perceval painted genre and biblical subjects, anchoring lessons from European masters into the Australian context. *Christmas Eve* (1948) holds a more tranquil and positive view of the world than would have seemed possible two or three years before. Unfortunately many works from this period were destroyed by the artist after criticism, so the intervening processes of healing or acceptance – even acquiescence? – cannot be traced.

JOY HESTER

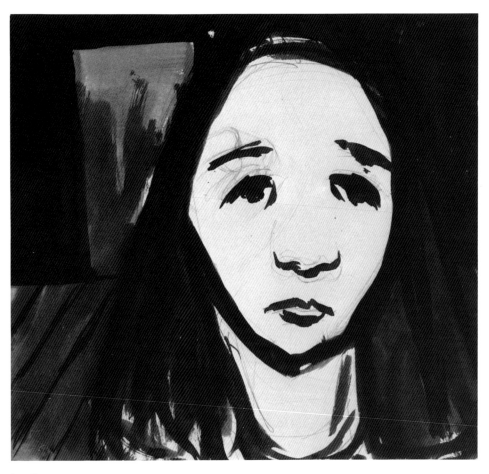

Joy Hester
Head of a young girl in a room
*c.*1945
Australian National Gallery, Canberra
No.147

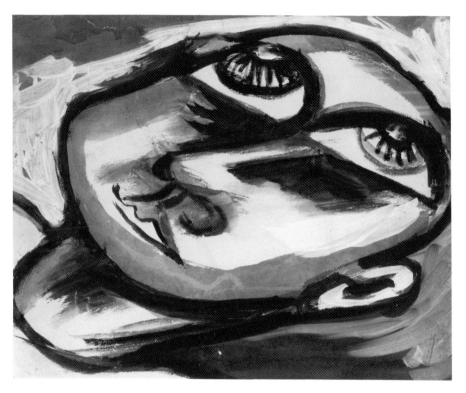

Joy Hester
Gethsemane
*c.*1946–47
Australian National Gallery, Canberra
No.151

'Gethsemane was the name Sunday [Reed] gave to the faceless doll she made and
stuffed with lavender from the ''Heide'' garden. Usually Gethsemane sat on
Sunday's bed where it was greeted personally by visitors: it had the quality of a
surrealist Personage.' In Hester's series of brush drawings in ink and gouache, the
doll metamorphoses from early works where it has a body and no facial features
to become just a face, with huge eyes staring sightlessly upwards.

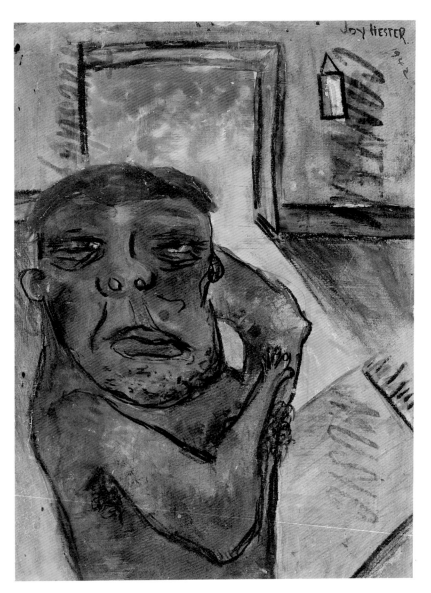

Joy Hester
Harry
1942
University Art Museum, University of
Queensland
No.145

144

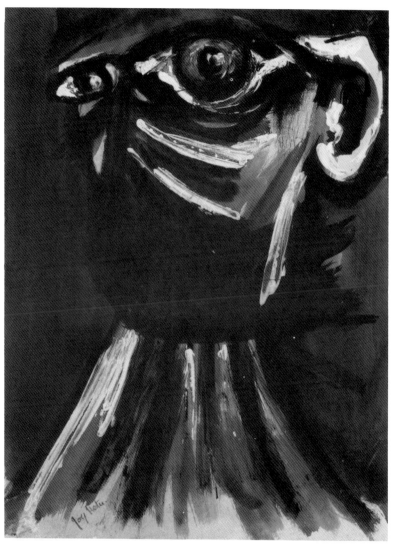

Joy Hester
Face
c.1947–48
Australian National Gallery, Canberra
No.154

Hester wrote: 'Somehow when I put brush to paper I start with an eye and the rest is dictated by that'. Her most characteristic work was drawn in ink, wash and gouache, usually with brush rather than pen. She often accompanied her paintings with her poems, regarding them as complementary.

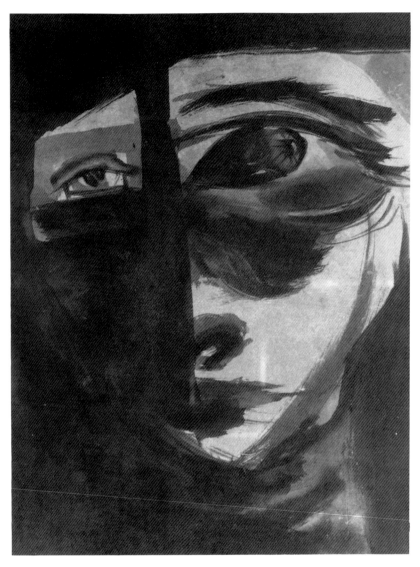

Joy Hester
Face (with crossbar)
1947–48
Heide Park and Art Gallery, Melbourne
No.155

146

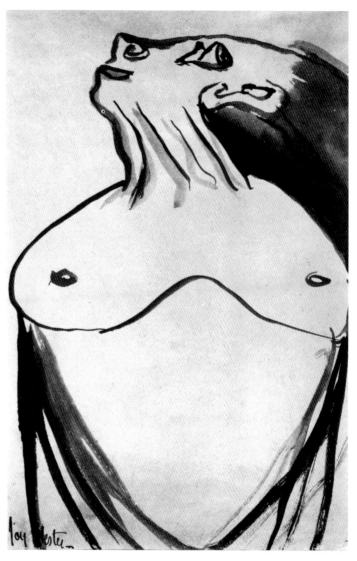

Joy Hester
From an Incredible Night Dream III
*c.*1946–47
Australian National Gallery, Canberra
No.152

The title of Hester's series of brush, ink and wash drawings derives from an image
in *Opium* by Jean Cocteau entitled *Night of December 30, 1928.* These works were
produced by Hester in the context of the immediate post-war period, when the
newsreels showed film of Nazi concentration camps, Bergen-Belsen in particular.

Joy Hester
Fun fair
c.1946
Albert Tucker, Melbourne
No.149

148

Joy Hester
Child of the high seas
c.1948
Australian National Gallery, Canberra
No.156

YOSL BERGNER

Yosl Bergner
Pumpkins
c.1942
Australian National Gallery, Canberra
No.158

Yosl Bergner
Aborigines in Fitzroy
1941
Art Gallery of South Australia,
Adelaide
No.157

The Communist Party had been agitating for equal rights from the 1920s –
Aborigines could not vote, were not Australian citizens, and in most states were
not permitted to move outside missions and reservations.

When Yosl Bergner arrived in Melbourne from Poland in 1937, he was
seventeen years old. 'I didn't know what an Aborigine was. He didn't look like a
Negro, but more like a Jew . . . I painted these people with a far-away look in their
eyes from generations before. They were displaced and I felt identified with them.'

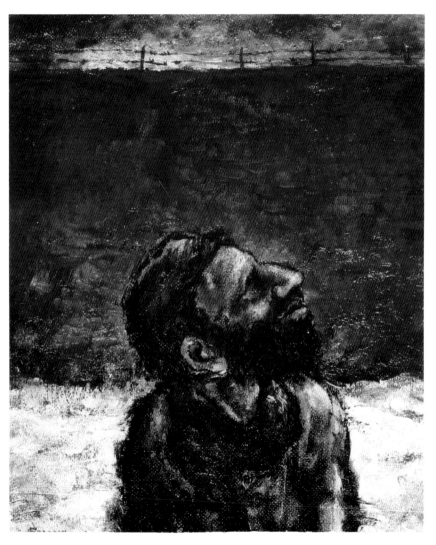

Yosl Bergner
The ghetto wall
1943
National Gallery of Victoria
Not exhibited

152

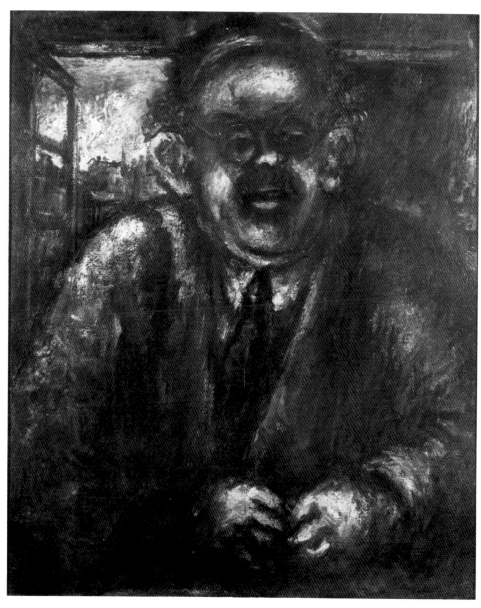

Yosl Bergner
Portrait of Mr I Segal
1944
Art Gallery of New South Wales,
Sydney
No.160

Noel Counihan

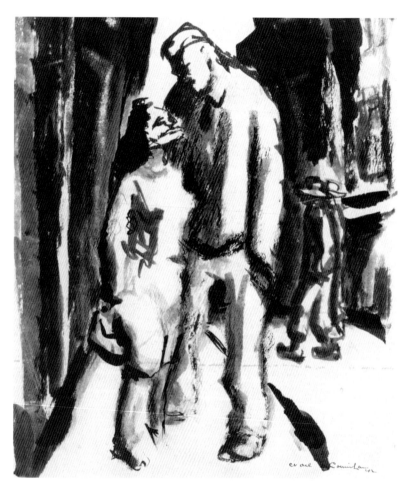

Noel Counihan
Woman and soldier (pick-up)
1942
Australian War Memorial, Canberra
No.165

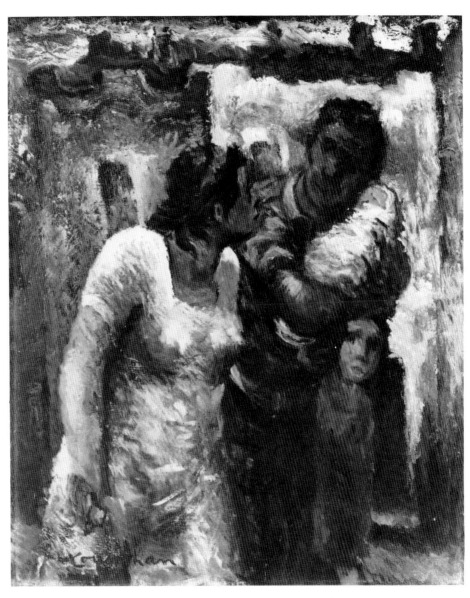

Noel Counihan
A soldier on leave
c.1943–44
Private collection, Melbourne
No.164

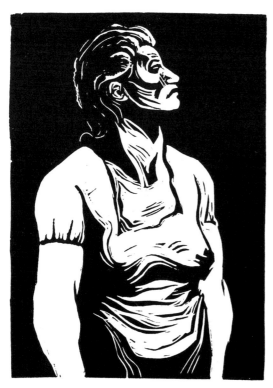

In the shadow of disaster . . . the wife

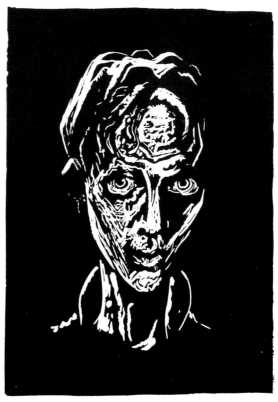

Brace-boy . . . first step to the pits

Noel Counihan
from the set of six linocuts *The Miners*
1947
Australian National Gallery, Canberra
Nos.168–171

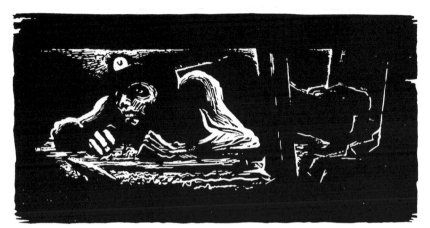

In the narrow seam

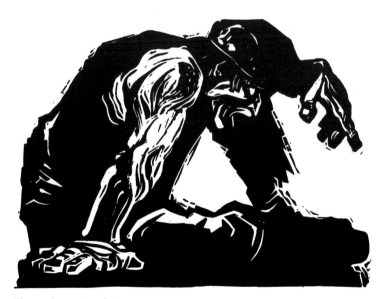

The cough . . . stone dust

157

VIC O'CONNOR

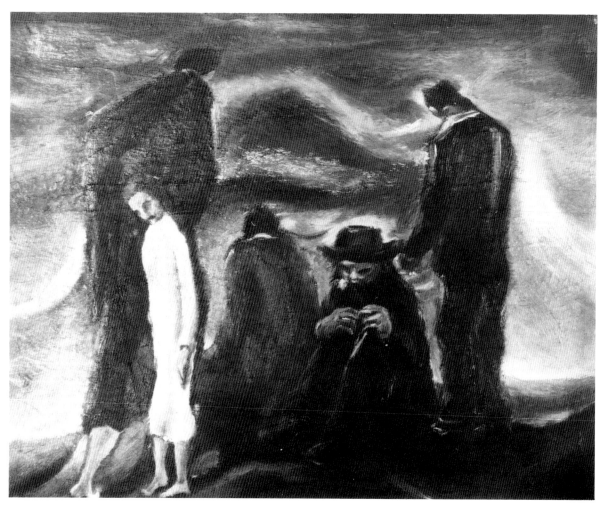

Vic O'Connor
The refugees
1942
Professor Bernard Smith, Melbourne
No.172

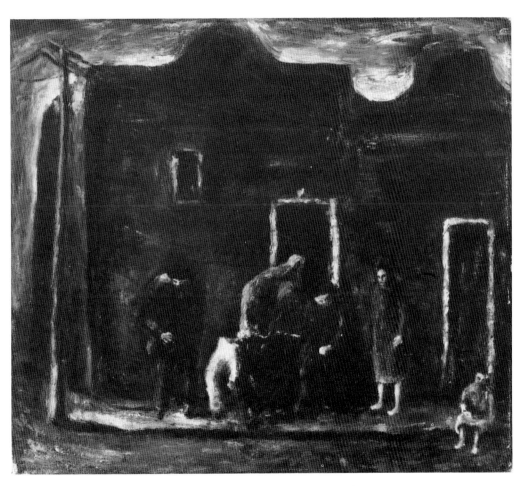

Vic O'Connor
The dispossessed
1942
Australian National Gallery, Canberra
No.173

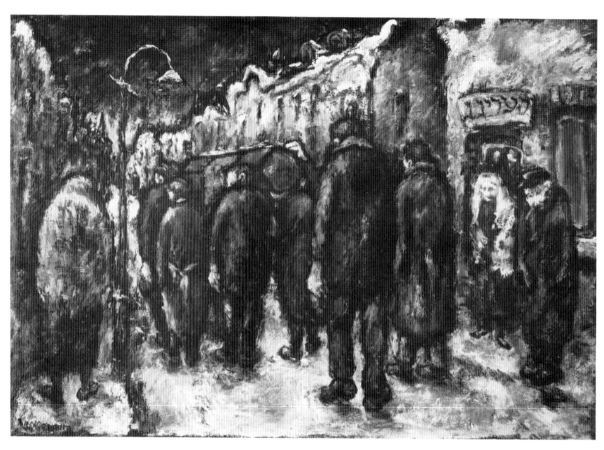

Vic O'Connor
The funeral
*c.*1943
Art Gallery of South Australia,
Adelaide
No.176

160

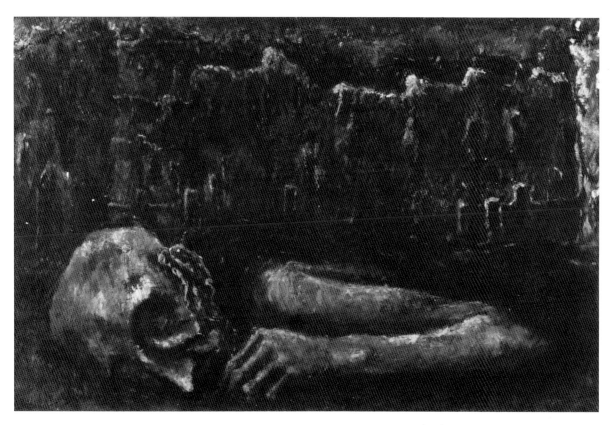

Vic O'Connor
The dead Jew
1942–43
Australian National Gallery, Canberra
No.175

LIST OF WORKS

Note: measurements are given in centimetres, height precedes width.
Where works are illustrated, page numbers are given in square brackets.

DANILA VASSILIEFF
(1897–1958)

1 [p.98]
Nocturne no 3, Commonwealth Lane
1936
Oil on canvas
52.7×47.3
Art Gallery of New South Wales, Sydney

2 [p.100]
Street scene with graffiti
1938
Oil on board
45.0×60.0
Private collection, Melbourne

3
Poverty and prostitution
*c.*1943
Oil on canvas
50.5×56.0
Australian National Gallery, Canberra

4 [p.99]
Theatre party
1944
Oil on composition board
55.5×67.0
Mr and Mrs Alan Geddes

Works on paper

5 [p.101]
Girl and boy in Fitzroy
*c.*1945–46
Gouache, brush and ink, pencil on paper
35.2×27.8
Australian National Gallery, Canberra

6
Portrait of a scholar
*c.*1946
Gouache on paper
50.7×37.8
Australian National Gallery, Canberra

7
Christ
*c.*1947
Gouache on paper
38.0×33.2
Australian National Gallery, Canberra

SIDNEY NOLAN
(born 1917)

8
Boy and the moon
*c.*1939–40
Oil on canvas mounted on composition board
73.3×88.2
Australian National Gallery, Canberra

9
Wimmera landscape (Landscape with train)
*c.*1943
Ripolin enamel on composition board
61.0×90.0
Heide Park and Art Gallery, Melbourne

10 [p.102]
Kiata
*c.*1943
Enamel on composition board
61.0×91.5
Australian National Gallery, Canberra

11 [p.103]
Bathers
1943
Ripolin enamel on canvas
64.0×76.5
Heide Park and Art Gallery,
Melbourne
Bequest of Sunday and John Reed
1982

12 [p.26]
Heidelberg
1944
Ripolin enamel on composition
board
91.0×121.0
Heide Park and Art Gallery,
Melbourne

13
Brighton Road State School
1944
Enamel on board
59.0×89.5
Art Gallery of South Australia,
Adelaide
Gift of Sidney and Cynthia Nolan
1974

14
Rosa Mutabilis
1945
Ripolin enamel on composition
board
91.5×122.0
Private collection, Melbourne

15
Gippsland incident
1945
Enamel on hardboard
91.5×122.0
Art Gallery of South Australia,
Adelaide
Gift of Sidney and Cynthia Nolan
1974

16 [p.16]
J.R.
1944
Synthetic polymer paint on
cardboard
63.5×76.2
Art Gallery of South Australia,
Adelaide
Gift of Sidney and Cynthia Nolan
1974

17
Head (Angry Penguin)
*c.*1945
Synthetic polymer paint on
hardboard
76.3×63.8
Art Gallery of South Australia,
Adelaide
Gift of Sidney and Cynthia Nolan
1974

18 [p.22]
J.P.
1945
Synthetic polymer paint on
cardboard
75.5×63.5
Art Gallery of South Australia,
Adelaide
Gift of Sidney and Cynthia Nolan
1974

19
Y.H.
1945
Synthetic polymer paint on
cardboard
63.5×76.2
Art Gallery of South Australia,
Adelaide
Gift of Sidney and Cynthia Nolan
1974

20 [p.17]
S.R.
1947
Synthetic polymer paint on
cardboard
63.5×76.2
Art Gallery of South Australia,
Adelaide
Gift of Sidney and Cynthia Nolan
1974

21 [p.14]
S.N.
1947
Synthetic polymer paint on board
75.8×64.5
Art Gallery of South Australia,
Adelaide
Gift of Sidney and Cynthia Nolan
1974

22
M.H.
1947
Synthetic polymer paint on
cardboard
63.5×76.2
Art Gallery of South Australia,
Adelaide
Gift of Sidney and Cynthia Nolan
1974

23 [p.18]
Albert Tucker
1947
Enamel on pulpboard
76.2×63.5
Art Gallery of South Australia,
Adelaide
Gift of Sidney and Cynthia Nolan
1974

The Ned Kelly paintings 1946–47

Note: in 1977 these paintings were given with love to the Australian National Gallery by Sunday Reed. Nolan painted them and gave them to her when he was living with her and her husband, John Reed, at 'Heide', Heidelberg, Victoria. The paintings are listed in sequence in accordance with the story.

24
Landscape
1947
Enamel on composition board
121.4×90.7
Australian National Gallery, Canberra

25 [p.104]
Ned Kelly
1946
Enamel on composition board
90.5×121.3
Australian National Gallery, Canberra

26
The burning tree
1947
Enamel on composition board
90.7×121.2
Australian National Gallery, Canberra

27
Constable Fitzpatrick and Kate Kelly
1946
Enamel on composition board
90.7×121.2
Australian National Gallery, Canberra

28
Morning camp
1947
Enamel on composition board
90.7×121.1
Australian National Gallery, Canberra

29
Township
1947
Enamel on composition board
90.7×121.5
Australian National Gallery, Canberra

30 [p.106]
Steve Hart dressed as a girl
1947
Enamel on composition board
90.6×121.1
Australian National Gallery, Canberra

31
Quilting the armour
1947
Enamel on composition board
90.4×121.2
Australian National Gallery, Canberra

32
Stringybark Creek
1946
Enamel on composition board
90.7×121.5
Australian National Gallery, Canberra

33 [p.105]
Death of Sergeant Kennedy at Stringybark Creek
1946
Enamel on composition board
91.0×121.7
Australian National Gallery, Canberra (purchased 1972)

34 [p.107]
The watch-tower
1947
Enamel on composition board
90.6×121.4
Australian National Gallery, Canberra

35
The alarm
1946
Enamel on composition board
90.5×121.3
Australian National Gallery, Canberra

36
The chase
1946
Enamel on composition board
90.5×121.3
Australian National Gallery, Canberra

37 [p.108]
The encounter
1946
Enamel on composition board
90.4×121.2
Australian National Gallery, Canberra

38
Marriage of Aaron Sherritt
1947
Enamel on composition board
90.7×121.1
Australian National Gallery,
Canberra

39 [p.109]
Defence of Aaron Sherritt
1946
Enamel on composition board
121.2×90.7
Australian National Gallery,
Canberra

40
The evening
1946–47
Enamel on plywood
90.5×120.1
Australian National Gallery,
Canberra

41
Bush picnic
1946
Enamel on composition board
90.4×121.2
Australian National Gallery,
Canberra

42
The questioning
1947
Enamel on composition board
90.7×121.1
Australian National Gallery,
Canberra

43 [p.110]
The slip
1947
Enamel on composition board
96.7×121.1
Australian National Gallery,
Canberra

44
Mrs Reardon at Glenrowan
1946
Enamel on composition board
90.8×121.5
Australian National Gallery,
Canberra

45
Siege at Glenrowan
1946
Enamel on composition board
121.2×90.3
Australian National Gallery,
Canberra

46
Burning at Glenrowan
1946
Enamel on composition board
121.5×90.7
Australian National Gallery,
Canberra

47
Glenrowan
1946
Enamel on composition board
90.9×121.2
Australian National Gallery,
Canberra

48 [p.112]
The trial
1947
Enamel on composition board
90.7×121.2
Australian National Gallery,
Canberra

Works on paper

49 [p.111]
Bushranger's head
*c.*1947
Charcoal on paper
31.8×25.2
Australian National Gallery,
Canberra

50
Bushranger's head
1947
Charcoal on paper
31.8×25.2
Australian National Gallery,
Canberra

51 [p.111]
Bushranger's head
*c.*1947
Charcoal on paper
31.6×25.3
Australian National Gallery,
Canberra
Gift of Sunday Reed 1977

52 [p.111]
Bushranger's head
*c.*1947
Charcoal on paper
31.8×25.8
Australian National Gallery,
Canberra
Gift of Sunday Reed 1977

53 [p.111]
Bushranger with mask
*c.*1947
Charcoal and enamel on paper
31.7×25.2
Australian National Gallery,
Canberra

ALBERT TUCKER
(born 1914)

54

Portrait of Adrian Lawlor
1939
Oil on paper mounted on
composition board
48.2×35.0
Australian National Gallery,
Canberra

55 [p.113]

Spring in Fitzroy
1941
Oil on paper on cardboard
56.0×43.6
Australian National Gallery,
Canberra
On loan from the artist

56 [p.114]

Pick-up
1941
Oil on cardboard
60.8×45.4
Australian National Gallery,
Canberra

57

Army shower
1942
Enamel on composition board
61.0×57.7
Australian National Gallery,
Canberra
On loan from the artist

58

The possessed
1942
Oil on plywood
54.4×76.0
Australian National Gallery,
Canberra

59

The prisoner
1942
Oil on plywood
76.5×60.8
Australian National Gallery,
Canberra

60 [p.115]

Death of an aviator
1942
Oil on plywood
74.6×55.5
Australian National Gallery,
Canberra

61

The bombing
1943
Oil on composition board
30.5×41.4
Australian National Gallery,
Canberra

62 [p.116]

*Image of Modern Evil: Spring in
Fitzroy*
1943–44
Oil on canvas on plywood
58.4×69.0
Australian National Gallery,
Canberra
Gift of the artist 1982

63

Battlefield
1943
Oil on composition board
61.1×91.8
Australian National Gallery,
Canberra

64 [p.117]

Sunbathers
1944
Oil on cardboard
59.2×86.0
Australian National Gallery,
Canberra

65

Face (Martin Smith)
1946
Oil on composition board
46.0×67.0
Australian National Gallery,
Canberra

66

Man's head
1946
Oil on cotton gauze on cardboard
63.4×76.0
Australian National Gallery,
Canberra

67 [p.68]

*Image of Modern Evil:
demon dreamer*
1943
Oil on paper on cardboard
40.8×50.8
Australian National Gallery,
Canberra
Gift of the artist 1982

68

*Image of Modern Evil:
woman and clown*
1943
Oil on canvas on composition
board
51.8×72.5
Australian National Gallery,
Canberra
Gift of the artist 1983

69
Image of Modern Evil 1
1943
Oil on canvas
30.4×35.7
Australian National Gallery,
Canberra
Gift of Barbara Tucker 1983

70
Image of Modern Evil 2
1943
Oil on composition board
30.4×39.0
Australian National Gallery,
Canberra
Gift of the artist 1982

71
Image of Modern Evil 3
1943
Oil on canvas on cardboard
22.2×29.0
Australian National Gallery,
Canberra
Gift of the artist 1982

72
Image of Modern Evil 5
1944
Oil on composition board
42.0×52.0
Australian National Gallery,
Canberra
Gift of Barbara Tucker 1983

73
Image of Modern Evil 6
1944
Oil on plywood
35.4×54.0
Australian National Gallery,
Canberra
Gift of the artist 1983

74
Image of Modern Evil 8
1944
Oil on cotton gauze on cardboard
44.3×54.3
Australian National Gallery,
Canberra
On loan from the artist

75
Image of Modern Evil 10
1944
Oil on cardboard
34.8×34.8
Australian National Gallery,
Canberra
On loan from the artist

76
Image of Modern Evil 11
1944
Oil on composition board
21.7×30.3
Australian National Gallery,
Canberra
Gift of Barbara Tucker 1984

77
Image of Modern Evil 12
1944
Oil on cardboard
32.7×24.6
Australian National Gallery,
Canberra
On loan from the artist

78 [p.118]
Image of Modern Evil 14
1945
Oil on composition board
70.5×56.0
Australian National Gallery,
Canberra
Gift of the artist 1981

79 [p.120]
Image of Modern Evil 15
1945
Oil on composition board
31.6×47.0
Australian National Gallery,
Canberra
Gift of the artist 1982

80
Image of Modern Evil 16
1945
Oil on plywood
48.3×61.0
Australian National Gallery,
Canberra
Gift of the artist 1981

81
Image of Modern Evil 19
1945
Oil on composition board
29.9×45.5
Australian National Gallery,
Canberra
Gift of the artist 1984

82
Image of Modern Evil 21
1945
Oil on plywood
66.4×91.5
Australian National Gallery,
Canberra
Gift of the artist 1986

83
Image of Modern Evil 22
1945
Oil on plywood
36.3×55.5
Australian National Gallery,
Canberra
Gift of the artist 1986

84

Image of Modern Evil 23
1945
Oil on composition board
91.4×68.7
Australian National Gallery,
Canberra
On loan from the artist

85 [p.119]

Image of Modern Evil 25
1946
Oil on cotton gauze on cardboard
75.7×63.2
Australian National Gallery,
Canberra
Gift of the artist 1987

86

Image of Modern Evil 29
1946
Oil on cotton gauze on cardboard
63.1×47.2
Australian National Gallery,
Canberra
On loan from the artist

87

Image of Modern Evil 30
1946
Oil on canvas on composition
board
50.7×45.7
Australian National Gallery,
Canberra
On loan from the artist

88

Image of Modern Evil 32
1947
Oil on composition board
31.8×35.5
Australian National Gallery,
Canberra
Gift of the artist 1981

89

Image of Modern Evil 33
1947
Oil on wood panel
37.2×50.0
Australian National Gallery,
Canberra
On loan from the artist

Works on paper

90 [p.121]

Victory girl
1943
Watercolour on paper
23.2×28.7
Australian National Gallery,
Canberra

91

Courtship
1943
Watercolour, pen and ink, brush
and ink on paper
11.4×16.6
Australian National Gallery,
Canberra

92 [p.122]

Female figure with tents and moon
1943
Brush and ink, watercolour
on paper
10.4×9.6
Australian National Gallery,
Canberra

93

Study, night image
c.1944
Pen and ink, brush and ink
on paper
16.0×13.8
Australian National Gallery,
Canberra

94

Study for Image of Modern Evil 23
c.1944
Pencil, pen and ink, brush and ink
on paper
18.8×13.7
Australian National Gallery,
Canberra

95 [p.122]

Study for Image of Modern Evil 23
c.1944
Watercolour, brush and ink, pastel
on paper
18.4×13.7
Australian National Gallery,
Canberra

96

Night image
c.1944
Pencil, pen and brown ink
on paper
10.2×15.2
Australian National Gallery,
Canberra

ARTHUR BOYD
(born 1920)

97

*Three heads (The brothers
Karamazov)*
1938
Oil on canvas mounted on
composition board
53.0×86.4
Australian National Gallery,
Canberra
The Arthur Boyd Gift 1975

98 [p.123]
Progression
1941
Oil on composition board
91.5×56.4
Heide Park and Art Gallery,
Melbourne

99
Man with sunflower
1943
Oil on cotton gauze on cardboard
54.0×70.6
Australian National Gallery,
Canberra
The Arthur Boyd Gift 1975

100 [p.125]
The baths (South Melbourne)
1943
Oil on cotton gauze on cardboard
62.5×76.0
Australian National Gallery,
Canberra
The Arthur Boyd Gift 1975

101 [p.124]
Lovers on a bench
1943
Oil on composition board
46.2×60.4
Australian National Gallery,
Canberra
The Arthur Boyd Gift 1975

102
The fountain
1943
Oil on composition board
48.8×58.6
Australian National Gallery,
Canberra
The Arthur Boyd Gift 1975

103
Butterfly hunter
1943
Oil on cotton gauze on cardboard
63.0×74.6
Australian National Gallery,
Canberra
The Arthur Boyd Gift 1975

104
Kite fliers
1943
Oil on canvas mounted on
cardboard
45.0×60.2
Australian National Gallery,
Canberra
The Arthur Boyd Gift 1975

105 [p.126]
The gargoyles
1944
Oil on cotton gauze on cardboard
51.0×63.2
Australian National Gallery,
Canberra
The Arthur Boyd Gift 1975

106
The orchard
1943
Oil on cotton gauze on cardboard
63.4×75.4
Australian National Gallery,
Canberra
The Arthur Boyd Gift 1975

107
The beach
1944
Oil on cotton gauze on cardboard
62.8×75.4
Australian National Gallery,
Canberra
The Arthur Boyd Gift 1975

108
The hammock
1944
Oil on cotton gauze on cardboard
63.0×75.4
Australian National Gallery,
Canberra
The Arthur Boyd Gift 1975

109
The cemetery I
1944
Oil on cardboard
63.3×75.4
Australian National Gallery,
Canberra
The Arthur Boyd Gift 1975

110
The hunter
1944
Oil on cotton gauze on cardboard
63.2×75.4
Australian National Gallery,
Canberra
The Arthur Boyd Gift 1975

111 [p.127]
Two lovers (The Good Shepherd)
1944
Oil on butter muslin on cardboard
53.6×72.3
Heide Park and Art Gallery,
Melbourne

112 [p.131]
The mockers
1945
Oil on canvas
84.5×103.0
Art Gallery of New South Wales,
Sydney

113 [p.128]
Melbourne burning
1946–47
Oil and tempera on canvas on
board
90.2×100.5
The Robert Holmes à Court
Collection

114 [p.129]
*The mining town (Casting the
money-lenders from the temple)*
*c.*1946–47
Oil, tempera on composition board
87.4×109.2
Australian National Gallery,
Canberra

Works on paper

115
*Woman holding back leg of dog
with trees*
*c.*1941–43
Ink on paper
26.0×29.0
Art Gallery of South Australia,
Adelaide
Purchased with the assistance of
the Visual Arts Board of the
Australia Council 1975

116
*Figures holding a weeping bird with
figures and howling dog*
*c.*1941–43
Ink and gouache on paper
21.0×30.0
Art Gallery of South Australia,
Adelaide
Purchased with the assistance of
the Visual Arts Board of the
Australia Council 1975

117 [p.130]
*Cripple in smoke from factory
chimney*
1942
Reed pen and ink on paper
22.7×28.8
Australian National Gallery,
Canberra
The Arthur Boyd Gift 1975

118
*Figure on couch with coffin, dog
and tree*
1942
Pencil on paper
26.5×29.3
Australian National Gallery,
Canberra
The Arthur Boyd Gift 1975

119
Lovers on a bench by lion's cage
*c.*1942
Reed pen and ink on paper
24.6×26.4
Australian National Gallery,
Canberra
The Arthur Boyd Gift 1975

120
*Flying swans over corpse in funeral
barge, Hastings*
*c.*1942–43
Reed pen and ink on paper
20.9×30.4
Australian National Gallery,
Canberra
The Arthur Boyd Gift 1975

121 [p.130]
*Study for the painting The kite
(Crucifixion)*
*c.*1943
Reed pen and ink on paper
30.0×21.0
Australian National Gallery,
Canberra
The Arthur Boyd Gift 1975

122
*Flying swan over corpse in funeral
barge with figure on shore*
*c.*1944
Ink on paper
26.0×36.0
Art Gallery of South Australia,
Adelaide
Purchased with the assistance of
the Visual Arts Board of the
Australia Council 1975

123
*John and Mary Perceval (Mary
Boyd)*
*c.*1944–47
Pencil on paper
37.0×28.0
Art Gallery of South Australia,
Adelaide
Purchased with the assistance of
the Visual Arts Board of the
Australia Council 1975

124
*Figures on a hill with snake:
'Agony in the Garden'*
*c.*1947–49
Pencil on paper
38.0×56.0
Art Gallery of South Australia,
Adelaide
Purchased with the assistance of
the Visual Arts Board of the
Australia Council 1975

JOHN PERCEVAL
(born 1923)

125 [p.132]
Boy with a cat
1943
Oil on composition board
59.0×43.8
Australian National Gallery,
Canberra

126
Train at station
1943
Oil on canvas on hardboard
40.0×60.0
The artist

127 [p.133]
Black-out train
1943
Oil on cheesecloth on cardboard
on composition board
64.2×53.8
Mr M. J. Dougherty

128 [p.136]
Flinders Street at night
1943
Oil on canvas
70.0×61.5
Private collection, Sydney

129 [p.134]
Boy crying in a Carlton street
1944
Oil on hardboard
72.0×40.0
The artist

130 [p.135]
Waiting at Murrumbeena Station
1944
Oil on canvas on hardboard
45.0×59.0
The artist

131 [p.137]
The merry-go-round
1944
Oil on canvas on cardboard
63.3×41.3
Australian National Gallery,
Canberra

132 [p.139]
Suburban roofs at night
1944
Oil on cheesecloth on cardboard
62.6×75.3
Heide Park and Art Gallery,
Melbourne

133
Murrumbeena railway station
1946
Mixed media on composition
board
59.0×77.2
Heide Park and Art Gallery,
Melbourne
Bequest of Sunday and John Reed
1982

134
Christ dining at Young & Jackson's
1947
Mixed media on composition
board
78.7×73.6
Mr and Mrs M. Alter

135
Crossing of the Red Sea
1947–48
Mixed media on composition
board
110.0×116.0
Mr and Mrs M. Alter

136 [p.140]
Flight into Egypt
1947–48
Mixed media on canvas on
hardboard
95.0×100.0
Art Gallery of Western Australia,
Perth

137 [p.141]
Christmas Eve
1948
Mixed media on canvas
78.0×97.0
The artist

Works on paper

138 [p.138]
*Landowner watching the shearer
work*
1942
Pencil on paper
32.9×20.2
Australian National Gallery,
Canberra

139
Children in a Carlton street
[Frontispiece]
*c.*1942
Pen and ink on paper
26.2×25.0
Australian National Gallery,
Canberra

140
The train (with self)
*c.*1942
Pen and ink on paper
29.3×26.3
Australian National Gallery,
Canberra

141
Escapist escaping
c.1942–44
Pen and ink on paper
20.2×25.3
Australian National Gallery,
Canberra

142 [p.138]
Horse attacking a man
1944
Reed pen and ink on paper
32.9×20.2
Australian National Gallery,
Canberra
Gift of the artist 1977

143
The Tivoli
1947
Pencil on paper
26.3×34.8
Australian National Gallery,
Canberra
Gift of the artist 1977

JOY HESTER
(1920–60)

144
Portrait of Michael Keon
1942
Oil on plywood
92.0×61.0
Heide Park and Art Gallery,
Melbourne

Works on paper

145 [p.144]
Harry
1942
Watercolour, pastel and charcoal
on cardboard
40.6×30.3
University Art Museum,
University of Queensland
Purchased with special help from
Philip Bacon

146
Man in an overcoat
c.1945
Brush and ink on paper
31.2×24.6
Australian National Gallery,
Canberra

147 [p.142]
Head of a young girl in a room
c.1945
Brush and ink, gouache on paper
26.4×29.2
Australian National Gallery,
Canberra

148
Head of a man
c.1945
Brush and ink on paper
29.6×24.0
Australian National Gallery,
Canberra

149 [p.148]
Fun fair
c.1946
Watercolour on paper
20.0×25.3
Albert Tucker, Melbourne

150
Gethsemane
c.1946–47
Brush and ink and gouache
on paper
30.5×24.5
Private collection, Melbourne

151 [p.143]
Gethsemane
c.1946–7
Brush and ink, gouache on
cream paper
25.0×30.9
Australian National Gallery,
Canberra

152 [p.147]
From an Incredible Night Dream III
c.1946–47
Brush and ink on paper
34.1×23.8
Australian National Gallery,
Canberra

153
City of dreadful night
c.1947
Brush and ink, gouache on
grey paper
29.7×24.0
Australian National Gallery,
Canberra

154 [p.145]
Face
c.1947–48
Brush and ink, gouache on paper
36.8×27.3
Australian National Gallery,
Canberra

155 [p.146]
Face (with crossbar)
1947–48
Brush and ink on paper
31.0×25.0
Heide Park and Art Gallery,
Melbourne
Bequest of Sunday and John Reed
1982

156 [p.149]
Child of the high seas
c.1948
Brush and ink, pen and ink on
paper
20.2×31.6
Australian National Gallery,
Canberra

YOSL BERGNER
(born 1920)

157 [p.151]
Aborigines in Fitzroy
1941
Oil on board
62.0×49.5
Art Gallery of South Australia,
Adelaide
South Australian Government
Grant 1978

158 [p.150]
Pumpkins
c.1942
Oil on composition board
79.0×96.4
Australian National Gallery,
Canberra

159
Seamstress
c.1943
Oil on canvas on composition
board
34.0×57.6
Private collection

160 [p.153]
Portrait of Mr I Segal
1944
Oil on canvas
56.0×46.0
Art Gallery of New South Wales,
Sydney

NOEL COUNIHAN
(1913–1986)

161 [p.54]
The New Order
1941
Oil on composition board
61.7×80.1
Australian National Gallery,
Canberra

162
The dispossessed
1942
Oil on composition board
37.6×48.2
Private collection

163
In the waiting room
1943
Oil on board
62.0×43.5
Art Gallery of New South Wales,
Sydney

164 [p.155]
A soldier on leave
c.1943–44
Oil on composition board
53.5×45.2
Private collection, Melbourne

Works on paper

165 [p.154]
Woman and soldier (pick-up)
1942
Brush and ink on paper
38.8×33.6
Australian War Memorial,
Canberra

166
The young wheeler
from the set of six linocuts *The
Miners* 1947
Linocut on paper
20.8×15.9
Australian National Gallery,
Canberra

167
The miner
from the set of six linocuts *The
Miners* 1947
Linocut on paper
23.1×17.0
Australian National Gallery,
Canberra

168 [p.157]
The cough . . . stone dust
from the set of six linocuts *The
Miners* 1947
Linocut on paper
14.7×20.2
Australian National Gallery,
Canberra

169 [p.157]
In the narrow seam
from the set of six linocuts *The Miners* 1947
Linocut on paper
11.9×23.6
Australian National Gallery, Canberra

170 [p.156]
In the shadow of disaster . . . the wife
from the set of six linocuts *The Miners* 1947
Linocut on paper
22.0×15.6
Australian National Gallery, Canberra

171 [p.156]
Brace-boy . . . first step to the pits
from the set of six linocuts *The Miners* 1947
Linocut on paper
22.0×15.6
Australian National Gallery, Canberra

VIC O'CONNOR
(born 1918)

172 [p.158]
The refugees
1942
Oil on board
42.0×53.0
Professor Bernard Smith, Melbourne

173 [p.159]
The dispossessed
1942
Oil on canvas
40.8×45.9
Australian National Gallery, Canberra

174
The hostages
*c.*1942
Oil on canvas
49.4×57.2
Private collection

175 [p.161]
The dead Jew
1942–43
Oil on canvas
46.4×69.5
Australian National Gallery, Canberra

176 [p.160]
The funeral
*c.*1943
Oil on composition board
45.6×66.0
Art Gallery of South Australia, Adelaide
South Australian Government Grant 1979

NOTES ON THE CONTRIBUTORS

Janine Burke wrote criticism, organized exhibitions and lectured in art history before writing fiction. She is the author of *Australian Women Artists, 1840–1940* (1980), *Joy Hester* (1983) and the novels *Speaking* (1984) and *Second Sight* (1986) which won the 1987 Victorian Premier's Award for fiction.

Christine Dixon researches and writes on Australian art of the 1930s–60s. She works at the Australian National Gallery, Canberra, in the Department of International Prints and Illustrated Books.

Richard Francis is Curator of the Tate Gallery, Liverpool. He selected the Jasper Johns retrospective exhibition, New York, 1984, and the Francis Bacon retrospective, London 1985.

Christopher Heathcote is researching an MA degree thesis on 'Avant-gardism in Melbourne' at La Trobe University. At present he teaches in the Fine Arts Department, University of Melbourne.

Max Harris, founder, editor and moving spirit of the *Angry Penguins* magazine, was the first to write about the Angry Penguins painters as a group. Poet, publisher, author, polemicist and journalist, in the latter capacity he has contributed a column to *The Australian* for twenty-two uninterrupted years.

Charles Merewether, art historian and writer, was curator of *Art and Social Commitment: An End to the City of Dreams 1931–1948* (Art Gallery of New South Wales, Sydney, 1983). He is currently preparing a book on *Fetishism and the Body in Contemporary Latin America* and an exhibition of contemporary Cuban art titled *Made in Havana*.

Sandy Nairne was Director of Exhibitions at the Institute of Contemporary Arts, London, and is now Director of Visual Arts at the Arts Council of Great Britain. Author of the book *State of the Art* (1987), he made a television series of the same name for Channel 4.

Barrett Reid, poet and author, has edited or been associated with the Australian literary magazine *Overland* for over twenty years. Chairman of the Victorian Premier's Literary Awards Committee, he was a founding member and Chairman of the Public Lending Right Committee and member of the Australia Council Literature Board. He is an executor of the Reed estate.

Bernard Smith is Professor Emeritus of Contemporary Art and formerly Director of the Power Institute of Fine Arts, University of Sydney. He is the author of *Place, Taste and Tradition* (1945), *Australian Painting* (1962), and *The Death of the Artist as Hero, Essays in History and Culture* (1988).